IF YOU CAN CUT, YOU CAN COLLAGE

FROM PAPER SCRAPS TO WORKS OF ART

HOLLIE CHASTAIN

QUARRY

Inspiring | Educating | Creating | Entertaining

Brimming with creative inspiration, how-to projects, and useful information to enrich your everyday life, Quarto Knows is a favorite destination for those pursuing their interests and passions. Visit our site and dig deeper with our books into your area of interest: Quarto Creates, Quarto Cooks, Quarto Homes, Quarto Lives, Quarto Drives, Quarto Explores, Quarto Gifts, or Quarto Kids.

First Published in 2018 by Quarry Books, an imprint of The Quarto Group,
100 Cummings Center, Suite 265-D, Beverly, MA 01915, USA.
T (978) 282-9590 F (978) 283-2742 QuartoKnows.com

Quarry Books titles are also available at discount for retail, wholesale, promotional, and bulk purchase. For details, contact the Special Sales Manager by email at specialsales@quarto.com or by mail at The Quarto Group, Attn: Special Sales Manager, 401 Second Avenue North, Suite 310, Minneapolis, MN 55401, USA.

10 9 8 7 6 5 4 3 2

ISBN: 978-1-63159-335-2

Digital edition published in 2018

Library of Congress Cataloging-in-Publication Data available

Design: Debbie Berne
Photography by author

Printed in China

For my loudest cheerleader and biggest support.

CONTENTS

2 TECHNIQUES

3 PRINCIPLES OF COMPOSITION

4 YOUR TURN: EXERCISES AND PROJECTS

THE LOVE OF PAPER

If I wrote a love letter to paper, it would be handwritten in pencil on aged, stained vintage notebook paper, as it makes *the best* letters. I have collected, and one might even say hoarded, the most interesting scraps and bits of it for years, not knowing what I would ever do with it. I just wanted to have it with me, to look at whenever I wanted. I found it inspiring then and still do now. I want to encourage you to be inspired as well. Pull out those piles of music magazines from the 90s, that book with the dog-chewed cover, and the wallpaper scraps in the closet. Let's make some coffee, get creative, and give this beloved paper a new life.

1

GETTING STARTED

MATERIALS

In my history with collage, the materials came first. Before I had even considered collage as a medium, I had boxes and drawers of found paper and ephemera that I collected because I loved the look of it. Whether it was color combinations, graphics, typography, or a clipping from a magazine, all of the scraps in those boxes and drawers spoke to me in some way. All of those were distinctly *me*. So, when I started using these scraps to make work, the work became distinctly *me*. One of the great things about collage is that the materials that you use are what will make your work unique to you. There are so many options that it would be impossible to list them here, but this is a good beginning.

In the subsequent pages, you'll learn about materials for the following:

CUTTING
scissors (large/small)
knife (with varied cutting tips)
linoleum or wood block cut-
 ting tools

MEASURING
grid mat
ruler
vellum
transfer paper

COLOR AND LINE
pens (white/black)
graphite pencil
acrylic paint
gouache
watercolor
pastels
crayons
colored pencils
ink
paint pens
markers
spray paint

PRINTING
stamps
ink pad
wood block
linoleum block
rubber brayer
sponge

ADHESIVES
glue stick
gel medium
tape
Mod Podge
Nori Paste
wheat paste

**ODDS AND ENDS
(BUILDING A BITS BOX)**
buttons
wooden sticks
thread
needles
tape
feathers
felt
sequins

SUBSTRATES
book cover
wooden panel
canvas
cardboard
watercolor paper
Bristol board
found paper

PAPER, ETC.
vellum
graphite paper
found paper
magazines
fabric
book pages
scrapbook paper

CUTTING

The decision on whether to use scissors or a blade as your day-to-day cutting tool is a personal one. Try both tools for lines, curves, and any squiggly shape you can imagine and see what works best for you. It's also useful to have hole punches and paper edging scissors handy for fun and interesting shapes. You will also use block cutting tools for stamp carving.

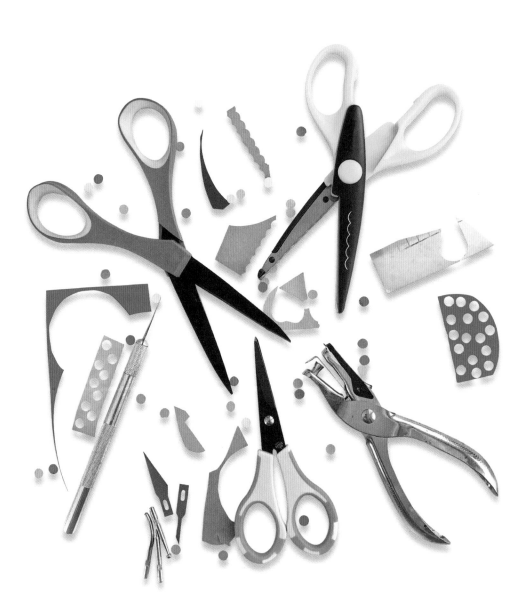

MATERIALS

- scissors (large/small)
- knife (with varied cutting tips)
- linoleum or wood block cutting tools
- hole punch

MEASURING

The following tools will assist with pattern making, cutting a straight line with a knife, finding the perfect fit when assembling geometric paper shapes, and the occasional need for a perfect circle or square. Finding a true center, setting a border, and even framing are so much easier when you don't have to guess.

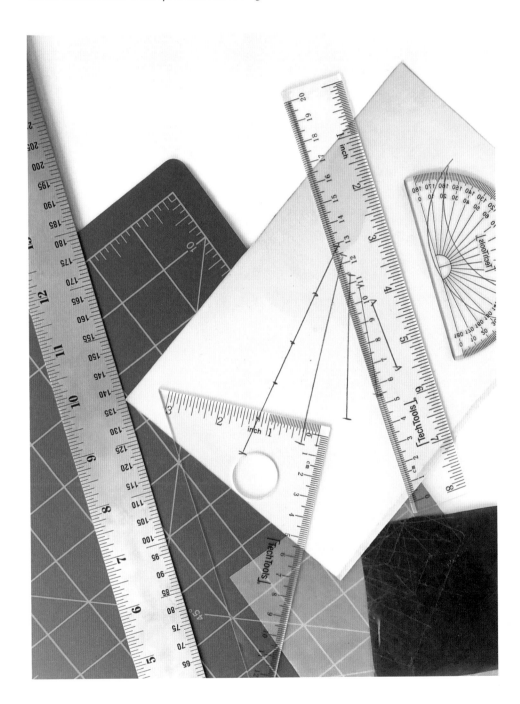

MATERIALS

- grid mat
- metal ruler
- clear plastic ruler
- angle finders
- vellum
- transfer paper

COLOR AND LINE

A wide assortment of mark making materials and color media allow for experimentation and play in your work. Taking advantage of this wealth of materials can add all of those colors and textures and waxy, painty, wonderful media to your collages. You can use these materials to make your own patterned paper, make painted sheets of paper, add drawn elements, create beautiful backgrounds, add to a narrative, and build luscious layers!

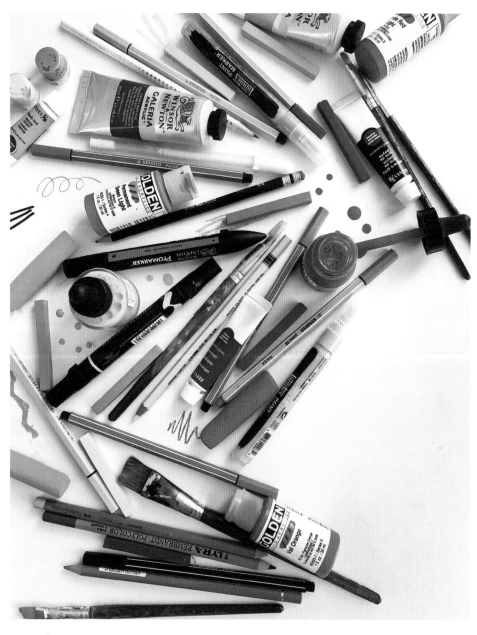

MATERIALS

- pens (white/black)
- graphite pencil
- acrylic paint
- paint brushes
- gouache
- watercolor
- pastels
- crayons
- colored pencils
- ink
- paint pens
- markers
- spray paint

PRINTING

A great way to create a background, build visual layers, or add texture and color to the surface of a collage is printing. You can buy stamps or make your own using sponges or a harder surface like wood or linoleum. Homemade designs made with wood or linoleum or PVC take a little more work, but it's a beautiful way to create a consistent body of work by integrating the same printed design in different ways throughout multiple pieces. Sponges add an interesting texture, and you can use many items as a stamp including cotton balls, leaves, potatoes, and wine corks.

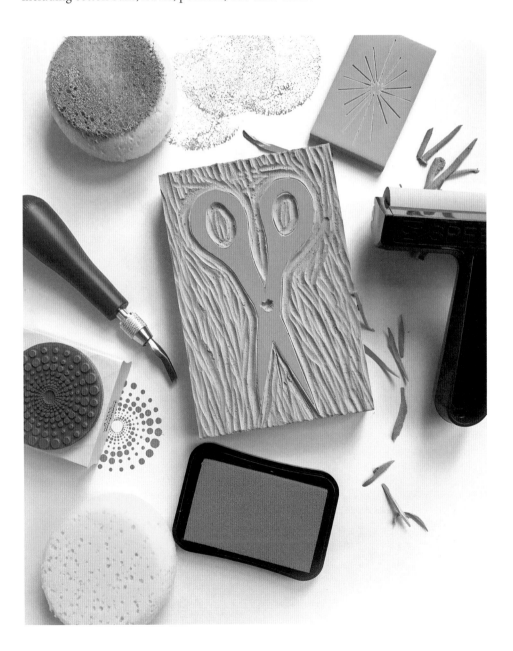

MATERIALS

- stamps
- ink pad
- wood block
- linoleum block
- PVC block
- rubber brayer
- sponge

ADHESIVES

Try a variety of adhesives. Depending on the techniques you tend to employ in your work, it's likely that in the end, you will gravitate back to one or two that work best for you. Since I started my collage career working on wooden panels, for years I only used gel medium; then, I started experimenting with a Saunders UHU Stic Glue Stick on found paper and mixed-media paper and I am now obsessed. There tends to be a specific adhesive that will work best for a project depending on the substrate and materials used. For paper on paper, a glue stick or tape will suffice. When building layers on a panel or canvas, it's nice to sandwich each layer in gel medium or Mod Podge. If you are attaching heavier elements, like wooden letters or cardboard, to a heavier substrate like a wooden panel, then heavy weight acrylic adhesives are best.

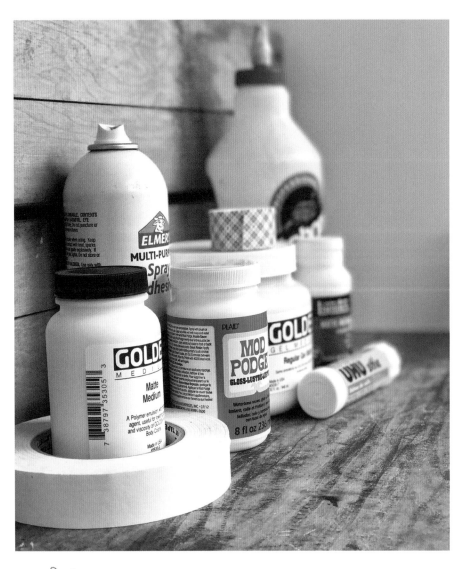

MATERIALS

- glue stick
- gel medium
- tape
- glue dots
- Mod Podge
- Nori Paste
- wheat paste
- acrylic adhesives
- foam mounting tabs
- wood glue

ODDS AND ENDS: BUILDING A BITS BOX

Layers are very important in many art forms, but collage especially benefits from a richly textured surface. You can build the main surface with paper and paint and adhesive, and sometimes, I pull out what I call my *bits box* for that extra texture, height, sparkle, fuzziness, or an organic element. There is no limit to what you can add to your own box, and I find that if I pick something up that has potential but no immediate use, one will present itself eventually. Staples include thread, needles, yarn, fabric, and wooden elements.

MATERIALS

- buttons
- wooden sticks
- thread
- needles
- yarn
- tape
- feathers
- fabric
- felt
- sequins

SUBSTRATES

This is another category where this list presents my day-to-day favorites, but really, the options are endless. Much like painting, you can collage anything from lampshades to tabletops. When choosing a substrate, it's good to consider the thickness and weight of the elements you will be adhering, as well as the adhesive itself. If I am making a lightweight clipped paper collage and am using a glue stick, then any paper with some weight to it will be fine such as watercolor paper or Bristol board. If you want to build up layers by sandwiching your elements in a gel medium, then a stronger substrate such as a wooden panel will work best.

MATERIALS

- book cover
- wooden panel
- canvas
- cardboard
- watercolor paper
- Bristol board
- found paper

PAPER

If a piece of paper speaks to you, then it is right for your collage. I have built entire large compositions that started with a tiny clipped image or the perfect color on an old record sleeve. Feel free to start your paper collection from this list, but I'm sure that soon you'll be scavenging from all corners of your house and beyond. (Candy wrappers and the paper tags from tea bags are super interesting when grouped together!) Collect interesting scraps even if you don't have a use or plan already in mind. A generous paper collection is important for that initial kick-start or as a shake-up if you find yourself with a creative block. Dump out that box or folder onto a big table and move the bits around until something jumps out at you. I promise that it will!

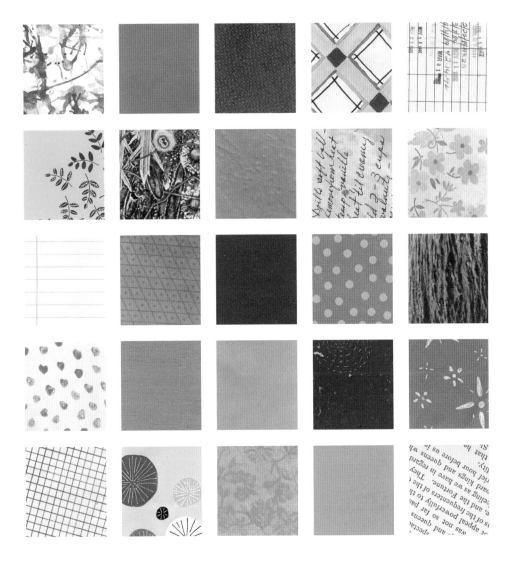

MATERIALS

- vellum
- graphite paper
- found paper
- magazines
- book pages
- scrapbook paper
- grid paper
- construction paper
- typing paper
- rice paper
- stickers
- photos
- maps
- wallpaper
- aluminum foil
- gold leaf

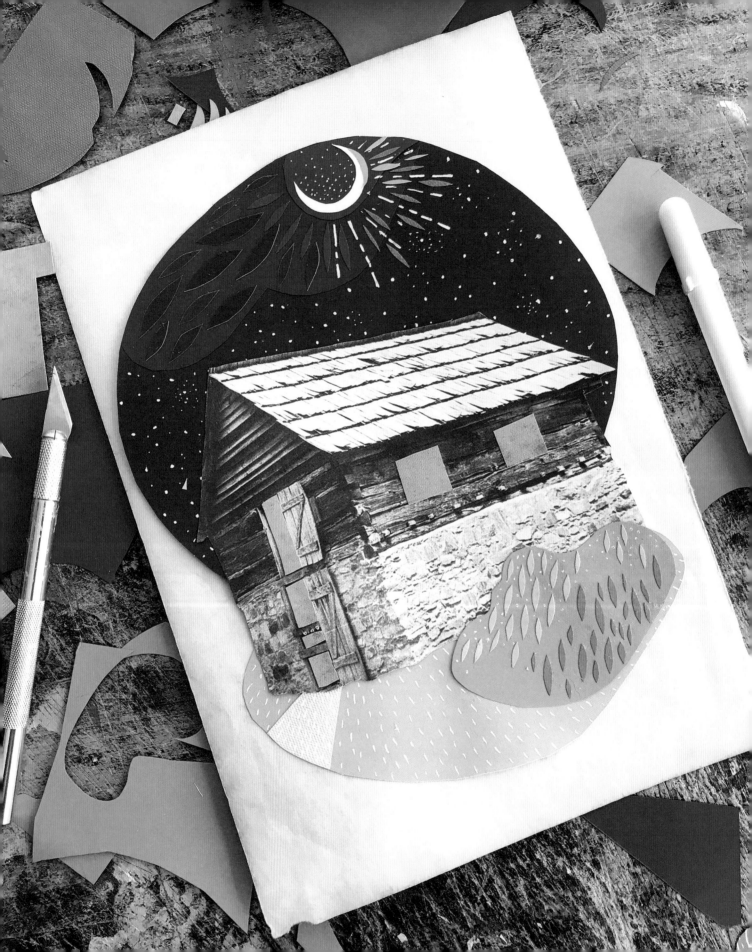

2

TECHNIQUES

Now that we have reviewed our materials, let's figure out what to do with them! The techniques in this section are tools as much as scissors and glue. We'll be painting, stitching, gluing, printing, and more. Each approach includes a materials list as well as ideas to try and examples. Give them all a try and then mix and match techniques and find what you love. That'll put you on a path to developing your own personal style. The key to these techniques is experimentation, so take risks, try new things, and break out of your creative comfort zone. That's when you stumble upon the magic.

In this section, we will explore the following techniques:

- Embroidery
- Painting
- Stenciling
- Drawing
- Stamping
- Monoprinting
- Patterned Paper
- Image Transfer
- Plexiglass Layering
- Wheat Paste
- Wall Art

EMBROIDERY

As much as paper on paper makes for infinite magical combinations, you can achieve fascinating textural interest by adding embroidered elements. You can also use embroidery to outline, add color, create a path that leads the eye through your work, or add a narrative element. If you haven't experimented with embroidery before, warm up those nimble fingers by stitching on some scratch paper. If you go off the path or make some unwanted pin holes in your active collage, don't worry—we have solutions for that. You can stick with thread and fill the area over the holes with the satin stitch or look back to the "Techniques" section for ideas and branch out. This is collage, after all! Glue a patch, find a sticker or tape, get a bigger needle, and make twenty more intentional holes for texture. Keep an open mind, don't get frustrated, and remember that the options are endless.

MATERIALS

- sturdy paper
- masking tape
- pencil
- needle
- embroidery floss or thread

This technique works best with thicker paper such as Bristol board, mixed-media paper, watercolor paper, or cardstock. You want it to be sturdier than copy paper, but thin enough to easily push a needle through. (If you are going to use thinner paper, make sure you don't skip the second step!)

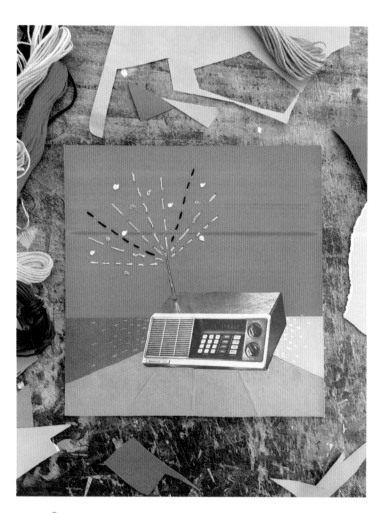

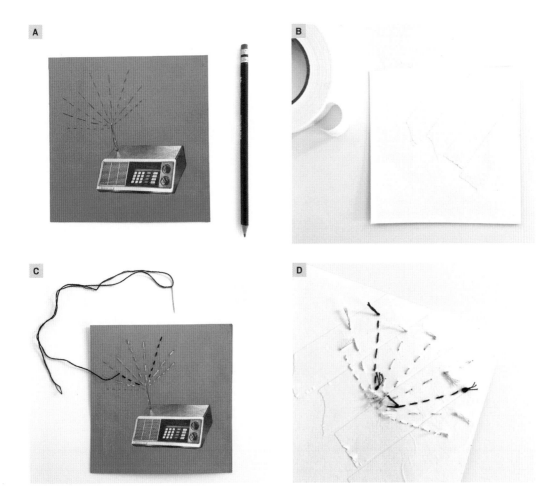

1. On the paper, sketch out the path you want to follow with your thread. A light pencil is best for lighter surfaces, but if you're sketching on a darker surface, a black pen or a white colored pencil will work perfectly. You will be covering the marks with thread, so don't worry about making it visible enough to not lose your way. (*See A.*)

2. Once you plan the position and path of your embroidery elements, flip your paper over and add a strip of paper tape, such as masking tape or low-tack artist tape, to the back side of the planned area. This will add extra durability to the substrate and keep the paper from tearing through. Place your paper on a window or lightbox if you're having trouble finding the path from the back of the paper. (*See B.*)

3. Pick a color, thread your needle, tie a knot at the end, and start stitching! Just like many things, experimentation is key to getting the look you want, but there are some tried and true stitches to get you started. My favorites are the satin stitch to fill larger areas with color, the back stitch or split stitch for lines, and French knots for perfect little dots of texture. (*See C.*)

4. When you have reached the end of your path or the end of your thread, whichever comes first, tie a knot on the back of your paper close to the surface. You want to pull it tight enough so that it doesn't slacken but not so tight that it might rip through. If there is excess thread, trim it off so there is a tail of about 2 inches (5 cm). (*See D.*)

PAINTING

Paint is incredibly versatile and wonderful. There are as many ways to use it in your collage work as there are ideas in your mind. You can paint whole sheets of that perfect color to use later. You can paint shapes and subjects to cut out and use in layering. You can paint directly onto your collage and directly onto your substrate to use as a base for your collage.

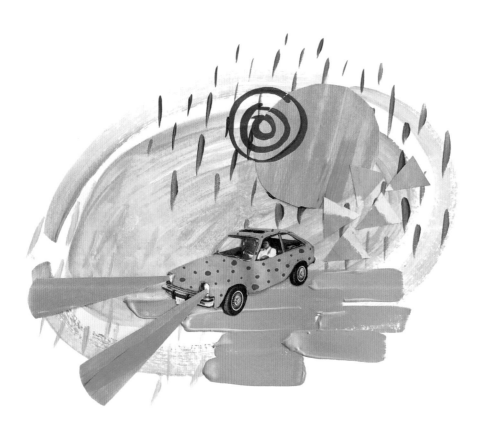

MATERIALS

- acrylic paint
- gouache
- watercolors
- paint brushes
- water
- papers of various textures and weights

- - - - -

Experiment with everything! Acrylic will have a shiny latex look. Gouache is matte and can be opaque or thinned to be more transparent. A wash of watercolor can add an interesting and textured background without taking over the focus. Use different shapes and sizes of brushes to see what type of mark you can make and take mental notes or physical notes in a sketchpad!

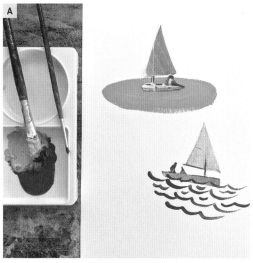

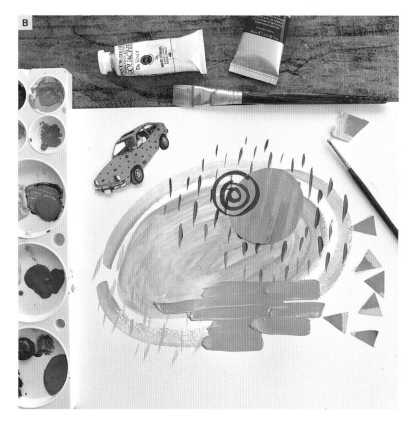

1 Mix paint with clipped objects to illustrate an idea or narrative. The two elements interact with each other in interesting ways. (*See A.*)

2 Layer and build your surface and don't be afraid to get messy with it. There is a time to be minimal and neat, but messy experimenting is fun, and you can really get to know the medium you are working with and what materials layer well on top of other surfaces. (*See B.*)

3 If I have mixed a great color and have paint left over after I am done using it for its original purpose, I paint sheets of book pages or other paper and set them aside to dry. I then keep these colorful sheets on hand to use later. (*See.C.*)

STENCILING

A stencil makes it easy for you to make a consistent design or mark over and over again on different surfaces. We all had those plastic sheets when we were young filled with cut out shapes and letters. You could follow the inside path with a pencil and make that perfect triangle every time. Those stencils are definitely still an option, and we're also going to also make a few of our own.

MATERIALS

- spray paint
- cardboard
- felt tip pen
- paper
- paint brush
- paint
- vellum
- carbon or transfer paper
- acetate
- store-bought stencil templates
- sandpaper

Everyone loves a good handmade, kind-of-squiggly shape or line, but if you are making a geometric style composition, then you are going to want that perfect triangle so that it fits exactly with the others. Protractors, angle finders, or a general-purpose shape stencil sheet are all great for this. Coins, coffee mugs, and juice glasses also make perfect circles.

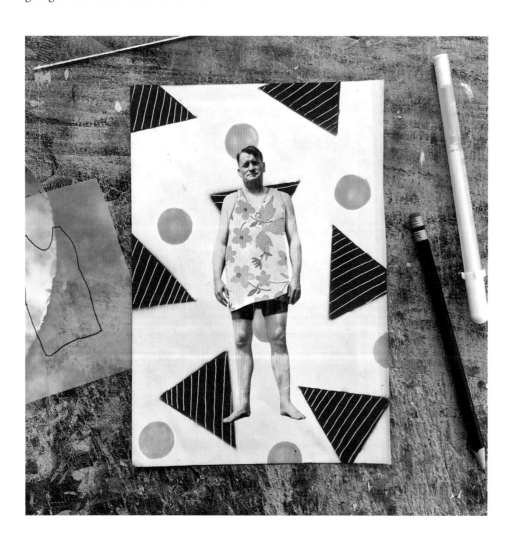

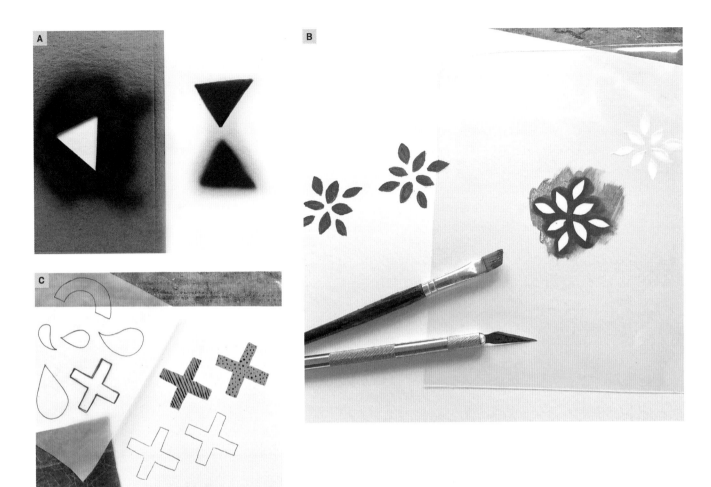

1. Start with a thinner piece of cardboard or a thick piece of paper such as Bristol board that is larger than the substrate you will be stenciling. If your design is more detailed, the thinner paper will be easier to work with. Start with a simple shape like circles and cut out a few in the center of the paper. In a ventilated area, apply spray paint to your stencil so that the circles are transferred to your substrate. Try this with the stencil close to the paper and then further away. You will get a different texture and edge with each distance. (*See A.*)

2. We're going to almost repeat the same process with different tools that will create a different result. This time, we will use a sheet of acetate as our stencil. This can be overhead projector film or sheet protectors that you can pick up at an office store. The thin material will allow for greater detail. If you want that perfect edge, you can use sandpaper to smooth the inside of your stencil after cutting. Now, lay your stencil on your substrate and paint over the top with a paint brush. Once dry, you can use your stencil over and over. (*See B.*)

3. This technique has been a part of my work since the very beginning because of its versatility and simplicity. Take a sheet of vellum or tracing paper and a black felt tip pen and draw a shape that you wish to repeat. Place your vellum over the top of your substrate where you wish the shape to be and place a piece of carbon paper between the two. Now, you can trace over your shape again and it will transfer to the substrate. You can repeat this until your stencil wears out and then just make another. (*See C.*)

DRAWING

This is a technique that I would advise for artists that are first time collagists—for those who don't necessarily want to leave their jars of beautiful pens and markers out of the process or might have developed a very distinct drawing style that they want to include that in their work. (This is how I started as well!) Whether you are new to collage or new to art in general, drawing is such a diverse and vast approach that there is something for everyone to latch onto in their own work when developing their style in collage. It's a way to add texture, color, unity, and movement while using favorite art supplies.

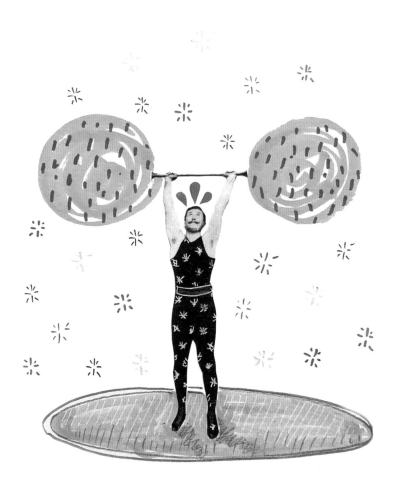

MATERIALS

- graphite pencils
- pens
- crayons
- colored pencils
- pastels
- papers of various textures and weights
- vellum or tracing paper
- carbon paper

Draw directly on your substrate and paper layers to add color and texture to your composition. If you use a marker, pen, or paint that is the same color as the paper elements in your collage for adding in the details, that is a visually interesting way to create unity.

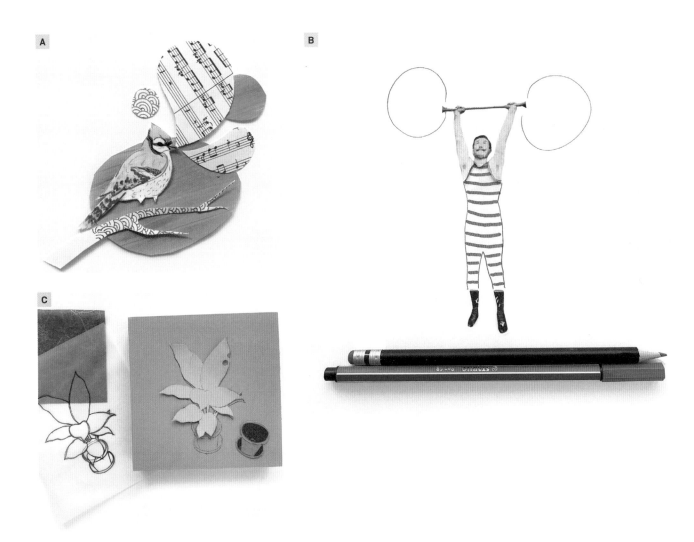

1 Fill up a sketchbook page with drawings or use an existing page of sketches and cut that apart to use as collage material. You can reassemble the page in a new way or use parts of it along with other paper elements. (*See A.*)

2 Take a clipped figure and cut away part of it. The most interesting part to take away is usually a middle section so that it leaves elements at the top and bottom. Now, draw that cut away part back in with a drawing instrument of your choice. You can recreate the original shape or make it completely different. (*See B.*)

3 Draw a subject or design on a sheet of vellum or tracing paper. Choose a substrate and transfer the drawing to the substrate surface using carbon paper. Now, you can use the vellum to collect different papers to fill in the shapes of your subject or design. It's a bit like making a quilt and so much fun. For this technique, I would advise a sturdier surface like a wooden panel and gel medium as an adhesive. (*See C.*)

STAMPING

There is a reason why we were all obsessed with stamping as a child—because it's fun! There's something very satisfying about the duplicative process of stamping. I remember sitting on my porch and filling a poster board with hundreds of tiny unicorn heads in all colors and that was a summer day spent well. Stamps can be as simple as a small store-bought rubber stamp and ink pad or as complex as an intricately carved linoleum block and many things in between. We're going to use a lot of household objects, but if you want a challenge, I have listed materials you can use to carve your own stamps.

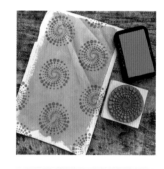

MATERIALS

- store-bought stamps
- cork
- sponge
- ink (pad or liquid)
- paint
- linoleum, PVC, or wood block
- linoleum or wood block carving tools
- brayer

- - - - -

Store-bought stamps and ink pads are fun and easy and can create an excellent repeating pattern to use as a background or to unify a composition through repetition.

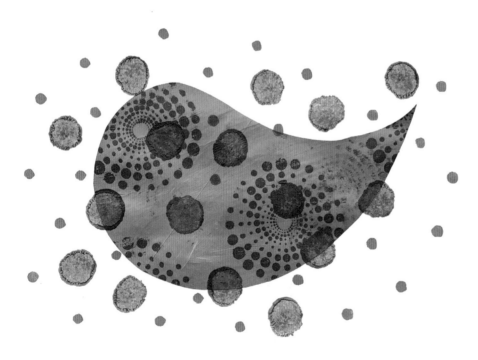

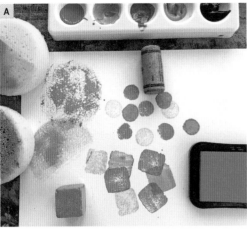

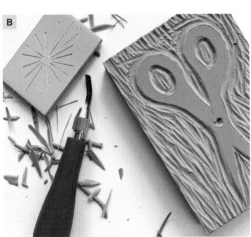

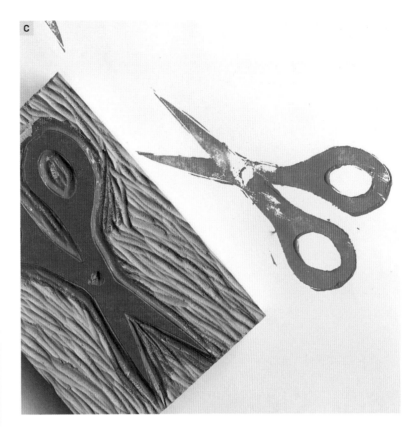

1 Wine corks, sponges, and potatoes are just a few of the things around the house you can use as a stamp. Use them just as they are with ink pads or paint to add organic shapes and texture or carve them into unique shapes. (*See A.*)

2 If you want to make your own a unique image that you can use over and over again, then you can find block printing and stamp materials at most craft stores and all art supply stores. PVC carving blocks are easy to use and a good first step to making your own. Remember, anything carved away from the surface will not appear when you stamp. Start with small pieces and a shallow carving tool. (*See B.*)

3 When carving a linoleum or PVC block, I always use a pen or pencil to draw my design on the surface and then use the tools to start taking all of the negative space away. It's a slow but satisfying process. You can test your progress at any time. Start by "inking" your surface with paint and laying it stamp down on your paper surface. Apply pressure to all areas and then lift away. If you find you have missed a few spots, you can wipe off the paint and continue carving. (*See C.*)

MONOPRINTING

A monoprint is a printing method where only one impression is made from the process. It's both very similar and completely different from a block printing or stamp technique where many multiples are made. There are many ways to create a monoprint, but we are going to use the most accessible and the most forgiving method, which makes it my favorite. I am using acrylic paint for this project because of the quick drying time and ease in cleanup, but you can also use printing ink.

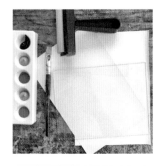

MATERIALS

- acrylic paint
- paint brushes
- brayer
- a piece of glass or plexiglass
- printmaking paper or sketch paper

Because acrylic paint dries so quickly, especially when painted as a thin coat, we are going to prep our materials first. Whether you have printmaking paper or are using regular sketch paper, the fibers will absorb the paint better if they are damp. Use a spray bottle or gently run the paper under the tap to wet it. You want it to be damp, but not dripping. Squeeze out your chosen paint colors and have that brayer ready.

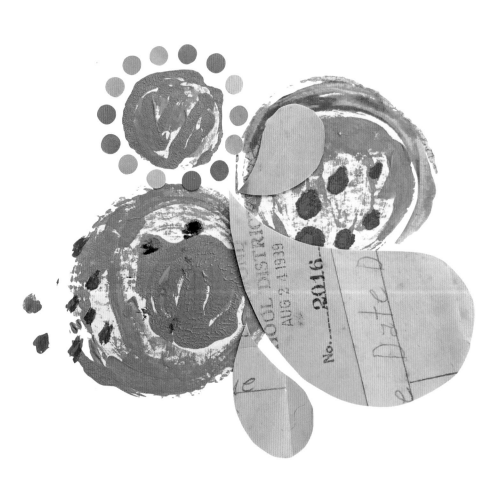

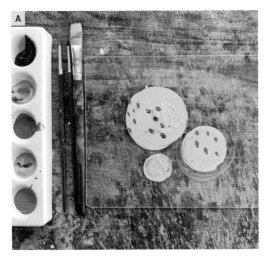

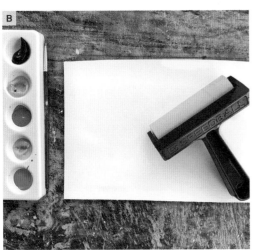

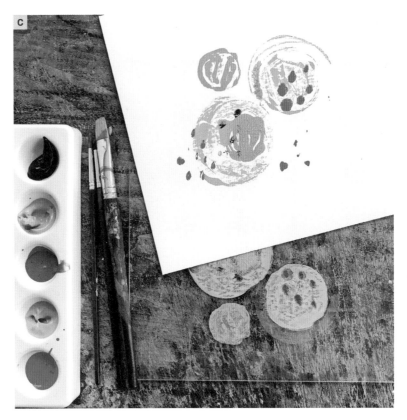

1 Paint your design on the surface of the glass or plexiglass. If you have them at the ready, you can also add very porous textures to the surface as well by using a doily, gauze, lace, or perforated paper. You can leave them on the top to create a negative space on your print or paint them to add color to that texture. (*See A.*)

2 Before anything has the chance to dry, lay your paper face down on your glass or plexiglass surface and use the brayer to apply pressure and roll the paper into the paint. This is why I prefer plexiglass over glass for this technique, so I can really put a lot of weight into it to get all that good color without worrying about breaking the plate. (*See B.*)

3 Now, peel the paper back and see the results. Set the print aside to dry, and then you can use it as a substrate or cut it up and use the elements in a larger collage. (*See C.*)

MAKE YOUR OWN PATTERNED PAPER

Homemade materials are a fun way to add personalized color, texture, and character to your collage. Wallpaper, fabric, or scrapbook papers from the hobby store are some examples of potential scissor-worthy bits that can give your almost completed piece that little something extra or kick-start your creativity on a blank surface. Sometimes, whether it's a special project or one with a specific theme, you might have a hard time finding something perfect. You might need green stars and can only find orange ones. You might desire thicker stripes. You might want a hearty, leafy vine, but the patterns available at the shop just won't do. What is the solution? Make them yourself! The possibilities are endless, and making materials from your own creative heart will help you make collages from your own creative heart as well. It's a perfect warm-up for a creative day.

MATERIALS

- paper
- pens
- pencils
- paint
- brushes
- ruler
- stamps
- tape

Use any acid-free paper such as sketchbook paper, book pages, or vellum. Patterns should be simple enough to replicate but textured enough to be interesting.

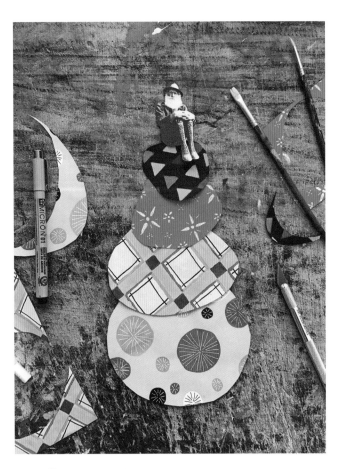

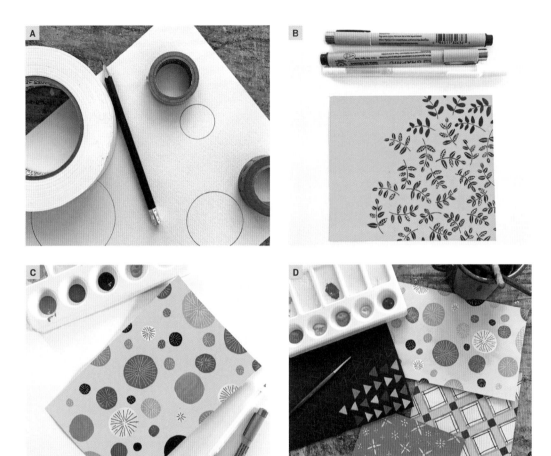

1 Trace around coins and cups for different-sized perfect circles. For stripes and grids, use a ruler to get that perfect line or use hand drawn lines for a more organic handmade look. Making a plaid pattern is always a fun project! (*See A.*)

2 If you know you will be cutting small shapes for a collage from the paper, use smaller designs. Larger designs will be lost if smaller shapes are cut from them. (*See B.*)

3 Paint larger shapes, such as circles, and when dry, add details on top with ink pens. Use white gel pen or white colored pencil on dark surfaces and experiment with different colored pens on light surfaces. (*See C.*)

4 If you feel stuck, look to your surroundings! A favorite article of clothing, the quilt your grandmother made, or the rug in your living room are all sources of great pattern ideas. Make several different patterned sheets using the same palette and see how well they work together. (*See D.*)

IMAGE TRANSFER

Sometimes, you may find an absolutely perfect image or one that you love, but can't seem to find a place for because of the size or color. Instead of clipping it, scan it and make a digital file so that if you are ever making a digital collage, you can open that folder and experiment. But there's a physical way to use these as well! Using gel medium, you can print this image and transfer the ink from the printer paper to the surface of your substrate. You can use wood, canvas, or other paper as long as it is sturdy and thicker than the paper that the image is on. Add the image to your collage, create a background, or print multiples of the same image and make a pattern by repeating.

MATERIALS

- gloss acrylic gel medium
- wide and flat paint brush
- water
- the image you want to transfer
- clean rag

- - - - -

Choose the image you want to transfer. If you are printing out your own, be sure and flip the image horizontally because it will be backwards in the transfer and use regular photo paper. If you are choosing a found image, find one with saturated colors and a matte finish. Anything with a glossy finish or thicker paper might not work as well, because the paper won't absorb the water and let go of the ink.

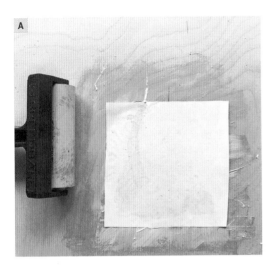

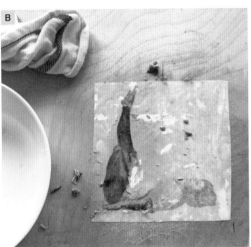

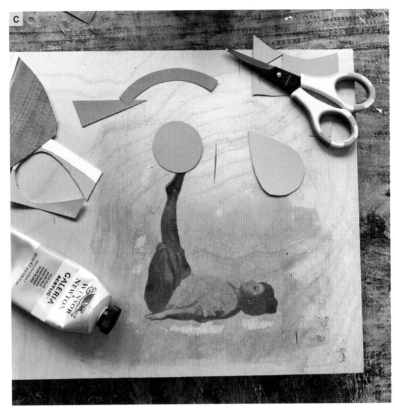

1 Use a paintbrush to apply a good amount of gel medium to the surface on which you want your image to be transferred and press the image face down into the wet medium. You can use a brayer to roll over the surface and make sure there aren't any air bubbles. Allow this to dry for at least an hour, but if possible, a longer drying time is better to make sure it's thoroughly dry. (*See A.*)

2 Dampen the back of the paper that the image was on with water and start gently rubbing to remove the paper. You can use your finger to start and a damp rag on the stubborn bits. (*See B.*)

3 Once the paper has all been removed, the ink will stay behind. When it's dry, you can paint or collage over it, cut it up, combine it with other transfers, or use it in any other way that you can imagine. (*See C.*)

PLEXIGLASS LAYERING

If you love experimenting with depth, this technique will bring your layers to a completely different level. By using multiple clear pieces of plexiglass as a substrate, you can then layer these pieces and create a neat 3D effect. Create a scene, play with abstract shapes, or bring an object to life. A fun challenge with this technique is to start with as many copies of the same image as you have layers of plexiglass. Start with the entire image at the very back and cut away more and more as you reach the "closest" part of the object. If I were using a face, I would start with a cutout of the whole face at the back and end with the tip of the nose and chin and maybe some hair on the very outer layer. It's great for experimenting and thinking about form.

MATERIALS

- several smaller same-sized sheets of plexiglass (I'm using 5 pieces measuring 8" x 8" [20 x 20 cm].)
- scraps of paper
- glue dots
- stainless steel stand-off mounts or other "floating frame" mounting hardware

Decide what clippings you want on each layer and place them into piles. You can always change your mind and rearrange as you go, but this will help you think through the composition to start. Generally, you want to put the largest shapes in the back and the smallest in the front so you don't cover elements completely and lose them in the composition.

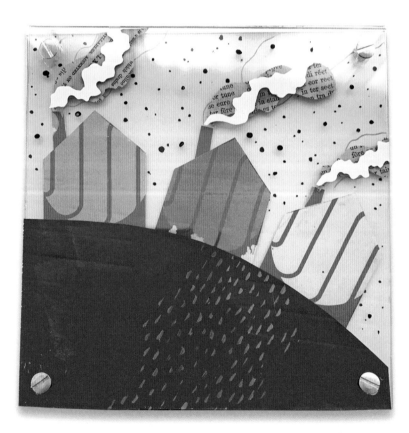

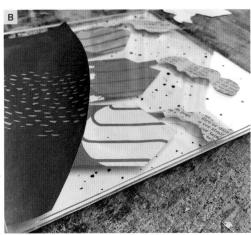

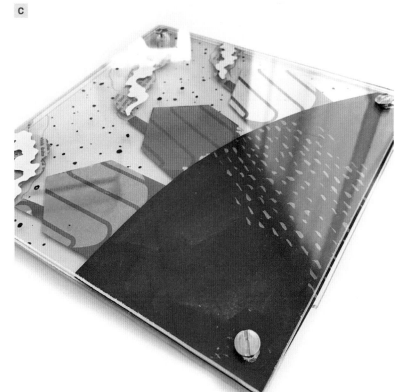

1　Put a small square of masking tape on the corner of each piece of plexiglass. This will keep the surface clean and tidy around the drill hole. Stack the sheets of plexiglass and use a power drill to drill holes through each corner all the way through all pieces. Make sure the hole is large enough for your hardware, both in width and depth. You can either take away or add a layer of plexiglass if the depth of the hardware doesn't match up. (*See A.*)

2　Start building the back layer of your collage on the surface of one of the plexiglass squares, slightly adhering them with glue dots. Continue to add to each layer, considering the placement to take advantage of the depth effect. If you add a wet element, such as paint, allow it to dry completely before you stack another layer. (*See B.*)

3　When your piece is complete and you are happy with all of the placement, align the holes on each corner and attach your hardware to keep everything snug and in place. You can hang this on the wall, stand it on its side for display on a shelf, or lay it flat on a tabletop. (*See C.*)

WHEAT PASTE WALL ART

We've gotten messy a few times so far, but this project might be the messiest in the most wonderful way. This is a street art technique that allows us to use those glue and paper skills on the largest substrates so far. It can be used on surfaces both indoors and outdoors, but paper-based art created inside will obviously last longer. And it's less pressure than painting, because with a little elbow grease, it can be scrubbed off, or if your work is outside, you can let nature remove it over the course of a few months.

MATERIALS

- flour
- water
- bucket
- paint or markers or any other art supplies you will use to make your street art collage
- masking tape
- large paint brush or paint roller
- large sheet of paper or smaller sheets like printer paper that you can tape together to make a larger piece

There are many recipes for wheat paste available online, but the simplest is made of wheat flour and water. Bring 4 cups (950 ml) of water to a boil and then add 1 cup (125 g) of wheat flour and combine, making sure you get rid of as many lumps as possible. Once your mixture starts looking a bit like glue, then it's ready! Use it soon or store it in the fridge.

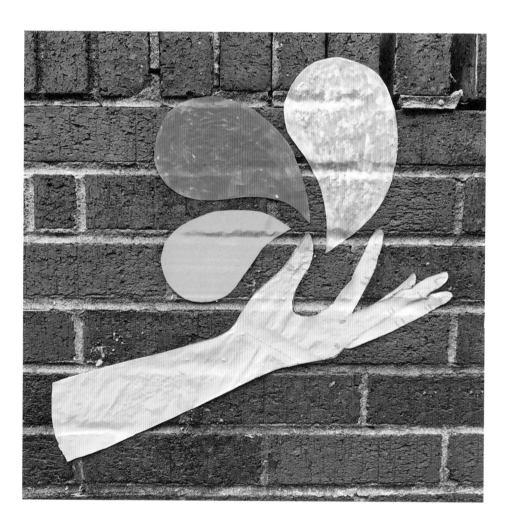

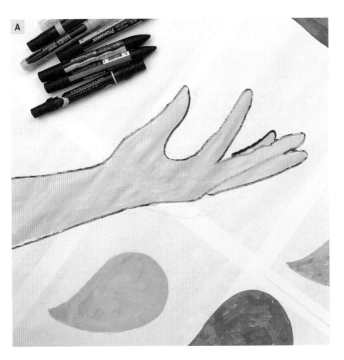

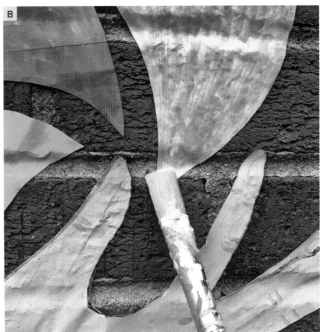

1 Use paint or markers to make your design and add color to the paper. When you're done and the paint has dried, cut along the edges of your shapes. (*See A.*)

2 Before we start gluing, remember that this project should be completed on your own property. It is eventually completely removable, but is still seen as vandalism if it is on someone else's fence or wall. So, pick an outside wall on your garage or backyard fence or even basement to make your street art masterpiece. Using the roller or large paint brush, paint a layer of the glue on the surface and then take your paper pieces and press them into the glue. Finish with another coat of wheat paste glue over the top and wait for it to dry. You can add multiple pieces and layers. The glue will dry clear. (*See B.*)

Decide how large you want your design to be and use the masking tape to make larger pieces of paper. You can have one large element or a collection of smaller ones. Part of the fun of this technique is you can make your collage larger than life, so go for it!

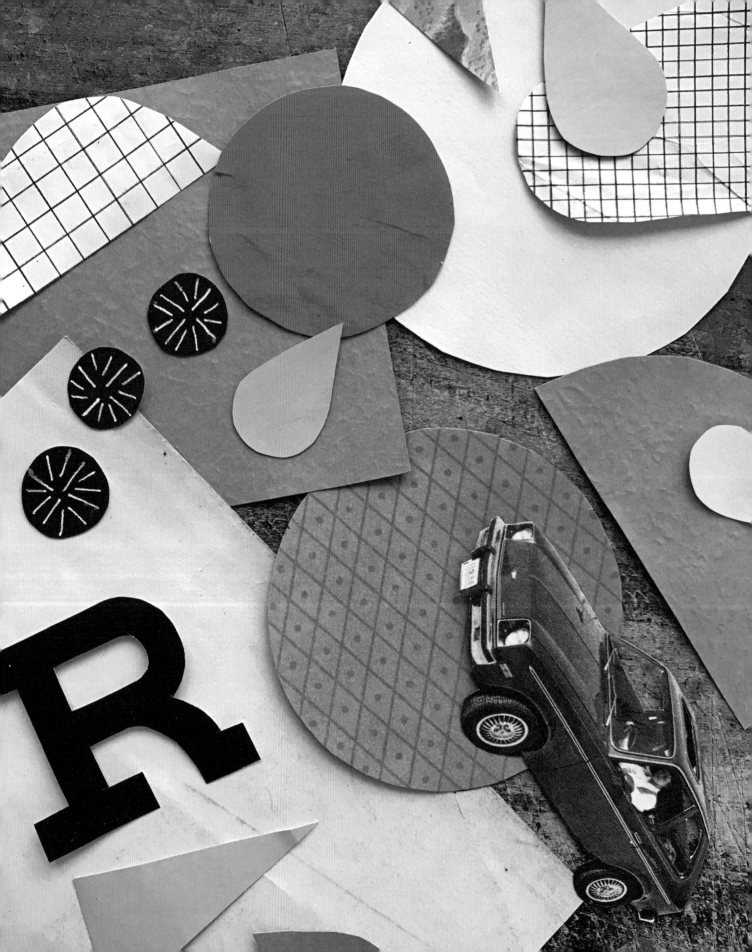

3
PRINCIPLES OF COMPOSITION

Basic composition is such a muddled and wonderful blend of math and gut instinct. You can put a grid on a canvas and measure, count, shrink, and enlarge elements with perfect proportion to get a fantastic result. And then sometimes, you just get a feeling of satisfaction when you slide an element a touch to the right, much like the feeling when the windshield wipers in your car sync to the beat of music. The great thing is that neither of these methods is right or wrong or better or worse. It takes a blend of both to round out your composition skills. In the next few pages, we'll explore my favorite rules, see some examples, and start to think about how to apply these ideas to your own work. If this feels overwhelming, and you find yourself thinking, "Hollie, I did not buy this book to graduate art school. I just want to glue some things together!" then that's okay too. Skip this part and work on the exercises. But I bet in the process of making a composition that you're working on looking "just right," you're following some of these rules naturally (that's where gut instinct comes in). There are markers on each page of examples so you can reference back to them.

In this section, we will explore the following principles of composition:

- Unity
- Balance
- Movement
- Rhythm
- Focus
- Contrast
- Proportion and Scale
- Depth
- The Rule of Thirds

UNITY

When you are looking at a composition and nothing within it distracts you from the whole, then you have unity. It's a sense of harmony and wholeness. A few ways to achieve this are using the same shape throughout, distributing the colors in your palette evenly, and repeating the main subject.

There are two types of unity: *unity without variation* and *unity with variation*.

 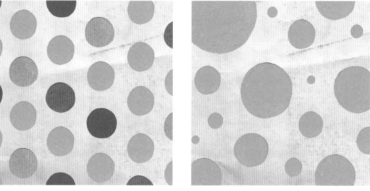

UNITY WITH VARIATION

If you are using circles to build your composition and all of your circles are blue and all of them are the same size, then you have *unity without variation*. This can be a bit visually boring, but it can also be calming and serene.

UNITY WITHOUT VARIATION

If you are using circles to build your composition and your circles are many colors and all of them are different sizes, then you have *unity with variation*. This is typically more visually interesting and can help add movement and flow.

Unity created using right angles

Unity created using similar shapes with interest added by splitting a circle

Unity created using the same
shape but varying color and size

BALANCE

Balance is the main gut instinct rule for me. This is the sense that the composition "feels right" and is not heavier on one side or the other. Having symmetry in a piece adds a sense of stillness and calm, whereas asymmetry creates tension and movement. You can balance a composition with shape, color, dense versus minimal subject matter, any combination of these, and more. For example, a small circle of dark color balances a large patch of light color. Small intense colors balance large muter colors. Small textured papers will balance larger smooth papers. Several smaller shapes balance a larger single shape.

Visual weight is what gives visual elements the ability to be balanced. There are two kinds of balance in composition: *symmetrical balance* and *asymmetrical balance*.

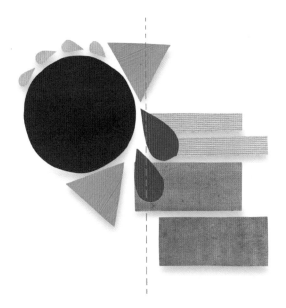

SYMMETRICAL BALANCE

If a line were to be drawn down the center of the page, both sides would be exactly the same, creating a *symmetrical balance*. This method can be used to show a sense of order, stability, and permanence.

ASYMMETRICAL BALANCE

If the two sides of the page are not identical, but there is a sense of balance in the arrangement, then this creates *asymmetrical balance*. This is where it gets especially interesting! Asymmetrical balance is typically more visually interesting and shows tension and movement in its arrangement.

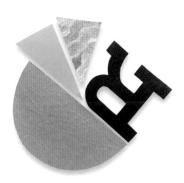

The dark complex shape on the right balances the muted simpler shapes on the left.

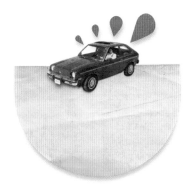

The extra weight at the front of the car on the left is balanced out by the red shapes growing larger to the right.

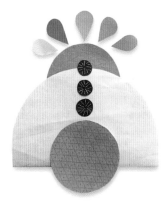

Compositions that are symmetrically balanced through shape can have interest added through color and pattern.

MOVEMENT

When you were drawing as a child and wanted to show movement, we all used the same technique. We drew lines around or coming from the moving object. This showed physical movement. We could make objects fast, wiggly, or bouncing, depending on the type of line we would use, and it definitely worked and still does.

A more subtle or refined way to show physical movement is to place objects within your composition in suspended animation, such as a bird in flight. Another way is to include diagonal or off-kilter lines in your composition that can also give the illusion of physical movement.

The horizontal line and centered focus make a still arrangement.

The addition of a diagonal line and an off–center focus add implied movement to the composition.

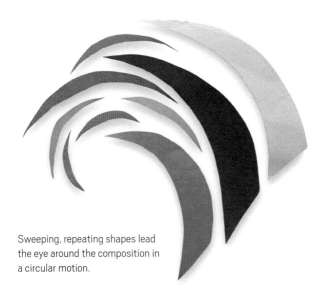

Sweeping, repeating shapes lead the eye around the composition in a circular motion.

There are other types of movement as well that involve the movement of the viewers eye around and within a composition. Placement of the objects, repeating shapes, and colors and implied and leading lines can guide movement.

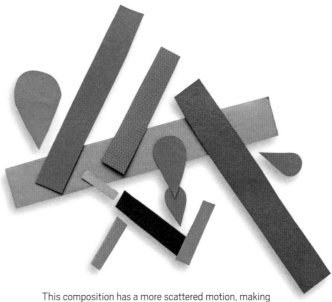

This composition has a more scattered motion, making the eye jump around and follow paths back and forth.

Use motion to draw the eyes towards a focal point.

RHYTHM

Is *tempo* a word you have ever thought of in relation to visual art? It's typically reserved for music, but your eyes can follow the beat of the elements in a composition the same way your ears can pick out rhythm, flow, and emphasis in a song. Patterns and relationships formed between positive and negative space in a composition build this visual rhythm for your eyes and different patterns make a different "sound." Large sweeping shapes swing your eyes from one side to the other. Implied lines guide up and down. If patterns are close with little negative space, the rhythm will seem quicker. Patterns that are evenly spaced and distanced will be a steady and stable rhythm.

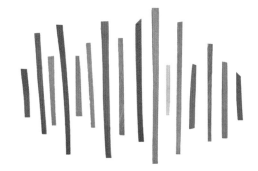

Repeating patterns close together move your eyes in a short and quick manner.

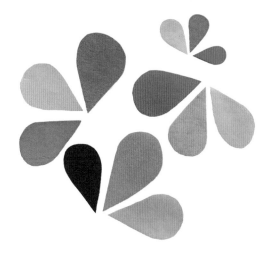

Repeating patterns that are large and sweeping create a different visual rhythm. The path that your eyes take loops more slowly around and through the composition.

The repetition of the curve leads your eye throughout the composition in a sweeping, bubbly, visual tempo.

Repeated shapes in a pattern form a very steady and stable visual rhythm.

Repeated patterns made from more diverse shapes make a steady but more visually interesting visual rhythm.

FOCUS

In most cases, you can look at a composition and, within a few seconds, know the main focus. It's where your eye is immediately drawn and wants to stay, and without it, the viewer can get a bit lost. There are many ways to draw attention to your focal point, including making it the largest, brightest shape and placing it right in the center. As reliable as that method is, you might sometimes want a more subtle or crafty route. It can be as slight as the addition of the very lightest or darkest color to highlight an area, a point of very high contrast, or the meeting point of leading lines, isolating the focus away from the other elements in a composition.

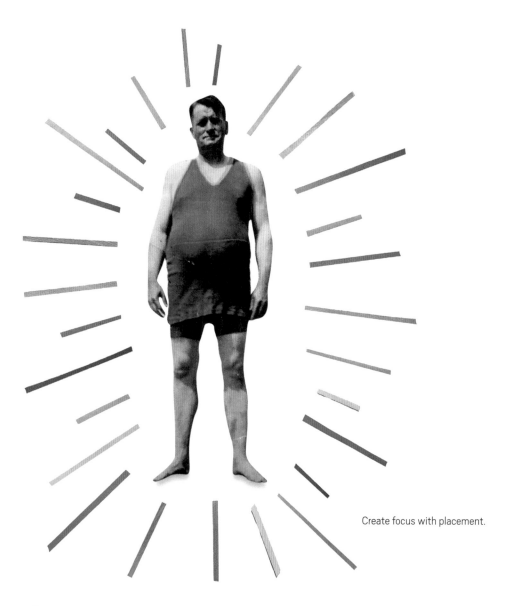

Create focus with placement.

Draw focus with a bright color alongside muted colors.

Leading lines draw the eye toward the focal point.

Show the focal point by isolating that element within the composition.

This is the "one of these things is not like the other" technique. Draw focus by adding a shape or color that does not appear in any other place in the composition.

CONTRAST

Contrast is the varying difference between the elements that make up your composition. When you think of visual contrast, usually the first thing that comes to mind is a large difference between light and dark. Black and white images with high contrast have a lot of white and black and very little grey in between. Very dark and very light tones are dramatic and can add interest and drama if your collage is feeling a little dull. There are other ways to show contrast as well through color, texture, and shape, and the amount of contrast can change the mood and tone, draw extra attention to your focal point, and move the eye through the composition.

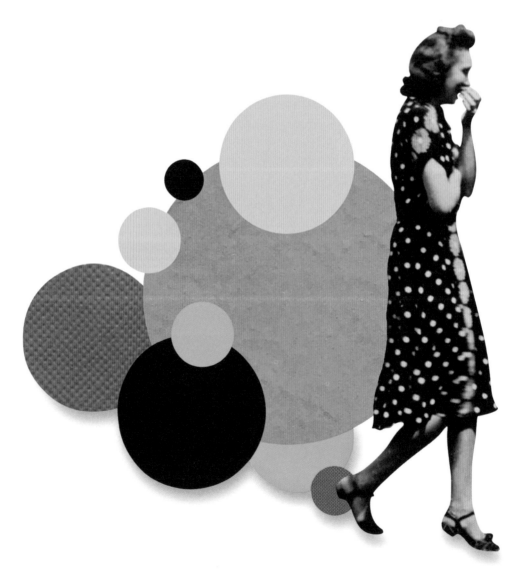

A great way to use contrast is through color. Complementary colors, colors that are directly across from each other on the color wheel, have a high contrast value when placed together in a composition. Especially if they are an intense hue and side by side!

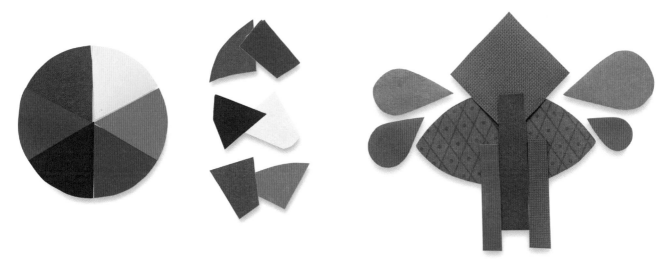

Contrast using color

Contrast using texture

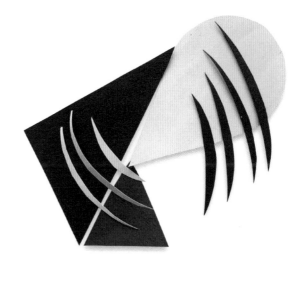

Contrast using dark and light

PROPORTION AND SCALE

Proportion and scale are often used side by side. They both deal with the size of elements and their relationship to the size of other elements but in different ways. If your composition includes a face, and you want to illustrate to the viewer that this person can see things that are 50 miles (80.5 km) away, then you make his eyes larger in comparison to the other features of his face. That is an example of the use of proportion. If the object that he is looking at is a tiger the size of a mouse (infinitely less terrifying), that is an example of the use of scale. It's an important element in illustrative work and storytelling. A tiger the size of a mouse versus a tiger the size of a bus tell two different stories, and neither of them are the same story that an average sized tiger tells. You can use proportion and scale to portray a feeling or emotion, define a focus, and add interest to your composition by manipulating the size of the parts in relation to each other.

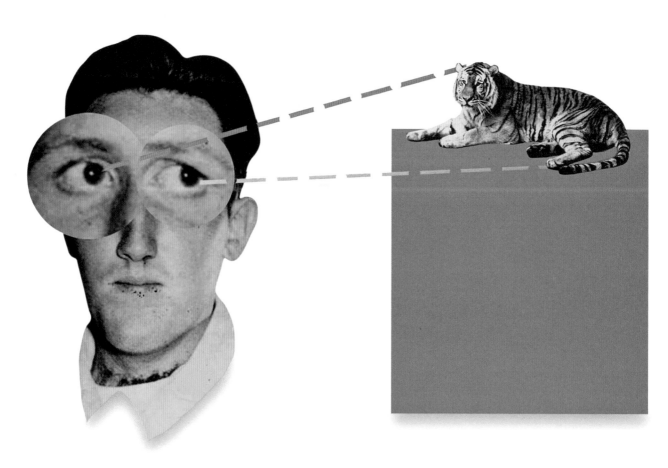

Proportion refers to the size of parts within a whole.

If the parts of a whole are equal, it can make the composition boring.

Dividing parts of a whole into unequal parts adds interest and tension.

Scale refers to the visual comparison between two whole elements.

A great difference in the size of the elements in a composition adds interest.

You can add emotion to the composition by making the larger shape loom over the smaller, which can add a sense of protection or overbearing.

DEPTH

Super-flat images can highlight design elements very well, but sometimes, you need that clipped picture of a chicken to look towering when compared next to a business man. Times like this are when the ability to show depth of field comes in handy. It's the illusion that you can look deep within a composition. There are a few ways to trick your eyes into processing a 2D surface into a 3D surface such as layering, changing color and vibrancy, placement, and the addition of a winding line or implied line like a path.

DEEP DEPTH OF FIELD
The higher an element appears in a composition, the further into the field of depth it will look. Also, elements will often look darker and more vibrant in the foreground.

SHALLOW DEPTH OF FIELD
An element will look like it is directly behind another if it is just slighter higher in the composition and layered behind.

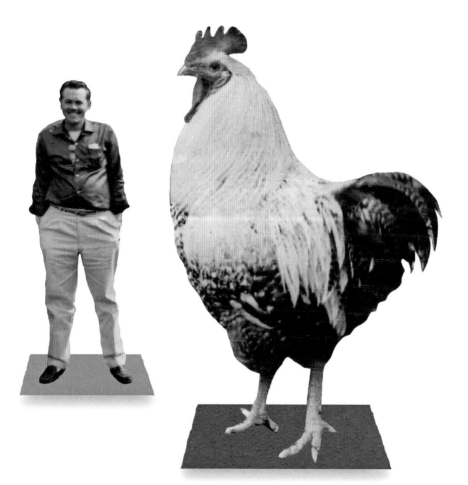

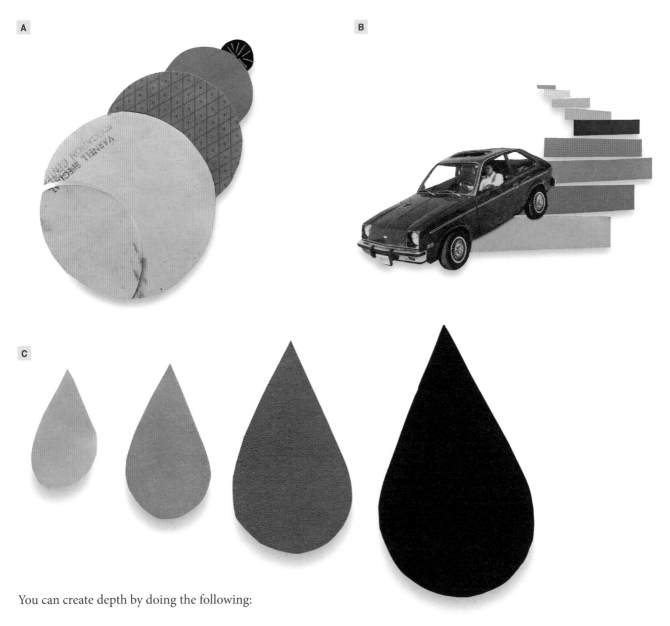

A

B

C

You can create depth by doing the following:

1 Overlapping and layering objects in front of each other (*See A.*)

2 Placing foreground objects lower in the composition and background objects higher in the composition. A winding path, either literal or implied, is another great way. (*See B.*)

3 Making foreground objects larger and more vibrant (*See C.*)

THE RULE OF THIRDS

To me, this is more of a guideline or a suggestion than a rule, but *The Suggestion of Thirds* doesn't carry the same weight, does it? This rule has been used in composition for as long as we have been composing to guide us when we don't want all of the focus right in the middle. It adds balance, interest, and keeps us from dividing the composition in half, either vertically or horizontally.

1 Take a sheet of vellum or tracing paper and draw two equally spaced horizontal lines and then two equally spaced vertical lines crossing like a tic-tac-toe grid. Now, you have four clear points of intersection that will help guide your composition. The goal of *The Rule of Thirds* to is place all main parts of your composition along these guiding points. (*See A.*)

2 Using your grid, arrange a visual focus right in the middle column between the points of intersection. This should look balanced and stable, but is it the most interesting? (*See B.*)

3 Now, move the visual focus to the right along the points of vertical intersection. Think back to what we learned about balance and add a secondary point of focus along the vertical points of intersection to the left. Your piece should now have added interest. (*See C.*)

Elements placed along the bottom row and left column

Elements placed along the bottom row and right column

When a composition spans across the grid, offset the most interesting parts, or focal point.

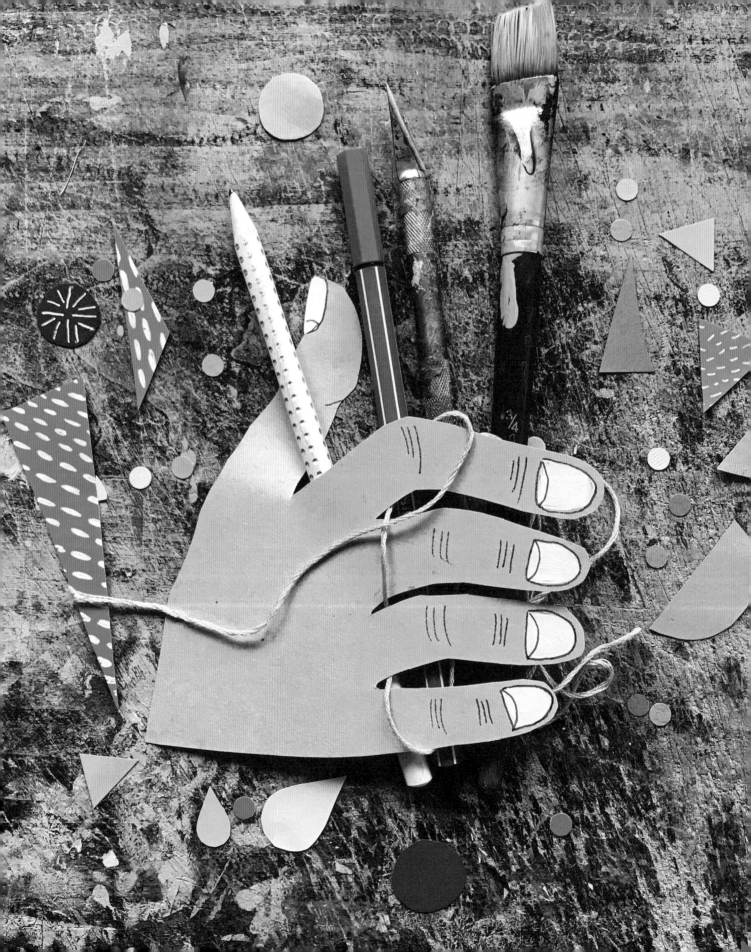

4

YOUR TURN!
EXERCISES AND PROJECTS

We enter the "Exercises and Projects" section armed with a creative arsenal of materials, techniques, and basic composition guidelines. This is where we will practice putting it all together. Each page will allow you to blend all that we have learned so far. In one exercise, we will use color and movement to demonstrate a new idea. We'll use all of those mark-making skills we practiced and our materials list to work out some textures and then use those textures to show focal point and contrast. Look back through the previous sections as needed for a refresher. Juggling these various aspects of collage making may seem like a lot to think about, but that's what this section is for—to practice until the process comes naturally as your learned skills combine with your creative mind to make beautiful collage work that you love.

In this section, we will explore the following:

- Mixing Elements
- Color
- Mirroring
- Repetition
- Background/ Foreground
- Layering

- Scale
- Contrast
- Juxtaposition
- Texture
- Negative Space
- Simple vs. Complex
- Flow

- Shape
- Line
- Using Type
- Using Nature
- Sketchbooking

MIXING ELEMENTS

This first project is going to loosen us up and put our creative mind on the right path to take full advantage of what we have discussed so far. It's very tempting for all of us to stick with what we know or what we're good at, but when we try new things, we give ourselves the opportunity to stumble upon something great. That's how you develop your personal style in a new artistic venture! Experiment, try everything, and hone in on what really speaks to you.

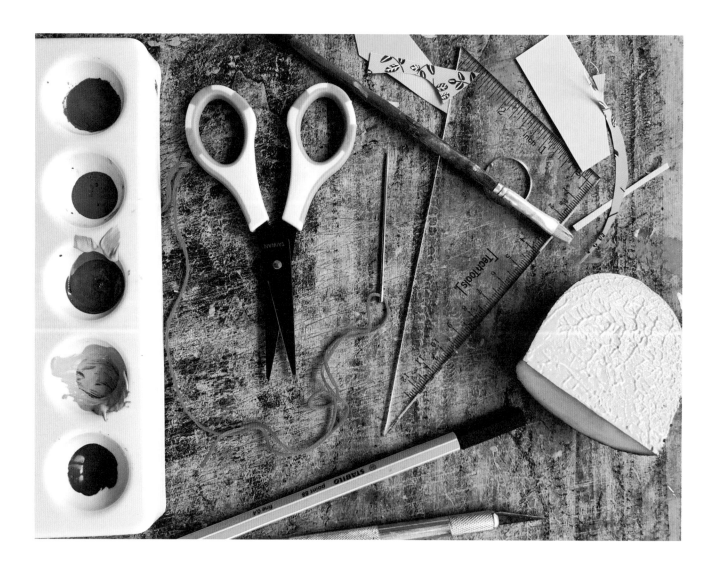

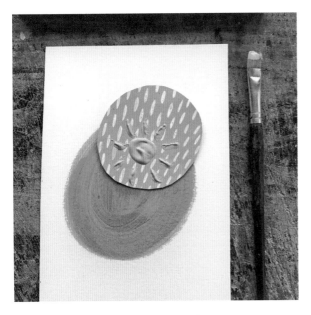

Combine painted elements and texture within a composition to draw the viewer's eyes to a focal point.

Combine stenciling and embroidery within a composition to create a sense of movement.

Combine patterned paper and drawn elements within a composition to create unity.

Build layers to create depth using a stamping method and clipped paper.

COLOR

Color has many roles in collage. It can represent something unseen such as energy, movement, or emotion. It can be used to balance or unify a composition, create a mood, or emphasize a focal point. With all of those important jobs, it might seem a little daunting to choose a palette (or even more difficult, just that one perfect hue) out of the millions of colors available. But a lot of the fun of collage is search and discovery, stumbling upon that perfect color in a magazine image or on an old label. You can dive in, mix your own colors, and paint your own paper, or you can treasure hunt and see what comes up!

Want extra help choosing colors? Try the color wheel! It's the perfect tool for solid palette options.

THE COLOR WHEEL

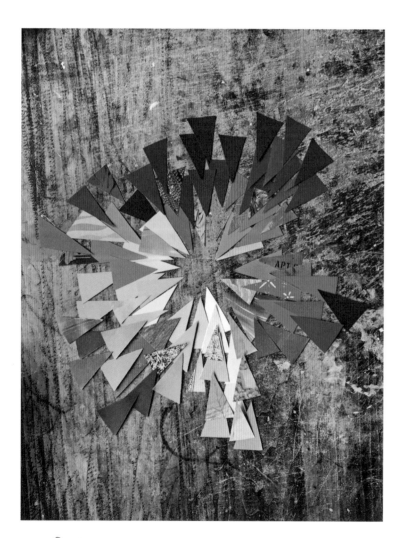

Monochromatic: One color and variations (shades or tints) of that color

Complementary: Colors across from each other on the color wheel

Split Complementary: One hue and two colors spaced equally from its complement

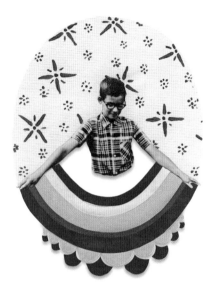

Pick a color palette that portrays a particular emotion to you. Think about your personal reaction to the colors you choose. For example, not everyone associates the color blue with sadness. Using either an abstract or illustrative approach, use the techniques we've learned to portray that emotion.

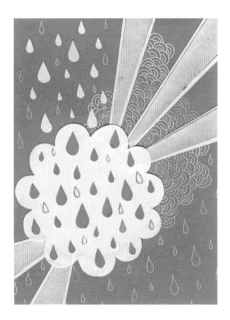

If you have chosen one color, add additional interest with texture-dense patterns and interactive characters.

If you have a varied palette, practice moving shapes and colors around to achieve different levels of balance.

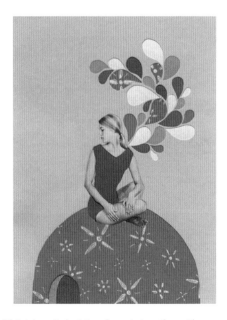

Maintain unity by tying elements together with similar colors.

MIRRORING

If you like to experiment with balance in your compositions, then this section will be extremely satisfying. We're going to practice making stencils using vellum and transfer paper, which is a helpful technique to master, takes full advantage of that beautiful paper stash that you have been building up, and continues to refine those scissor and knife skills. This might seem like a simple exercise, but its simplicity will allow you to focus on your pattern and color choices and recognize visual weight. You can mix texture-dense patterns, use bright and bold colors, contrast dark and light colors, or add any other elements that you desire to the composition.

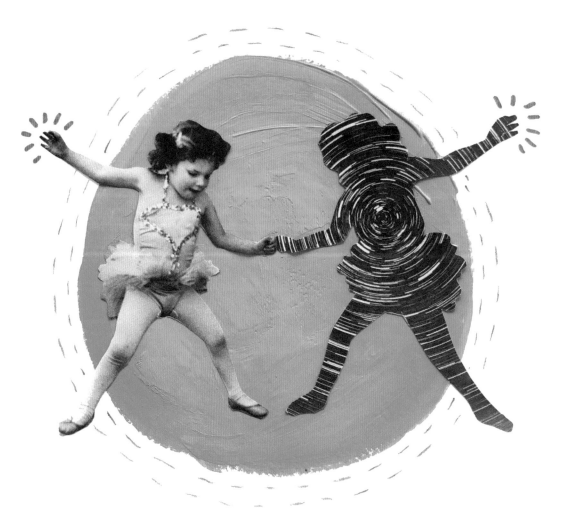

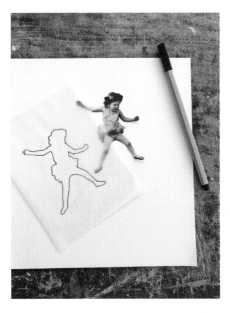

Clip an image from your magazine stash or choose one from your clippings pile. You want it to be simple enough to have a recognizable silhouette, yet have enough features to still be visually interesting. Using your vellum or tracing paper, make a stencil by drawing over the edges of your clipped image.

Now, use your vellum and transfer paper to make duplicates of your image. You can use solid paper, patterned paper, or other found imagery like a star field or open water. Make some duplicates facing in the same direction as the original and flip some in other directions by turning over the vellum stencil before retracing the image.

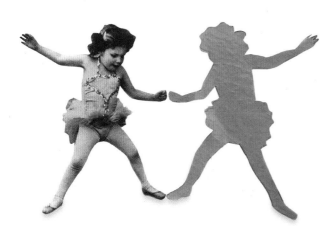

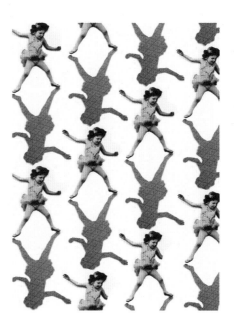

To mirror the image horizontally, place your original clipping and then choose a duplicate clipping facing the opposite direction and find a logical point where the two elements meet. If neither of the patterns or colors overpowers the other, this makes a perfectly balanced composition and also demonstrates unity with variation.

You can also mirror the image vertically or layer several to create a rhythmic pattern.

REPETITION

Unity, texture, movement, and rhythm would be so much more difficult to achieve without repetition. It is used to lead the viewer's eye around a composition and help identify a focal point. Using repetition in your work doesn't mean that you need to repeat an entire subject or even an entire shape. Repeating even a portion of a shape, like the right angle of a square or the curve of a circle, is enough to visually recognize it. Or, instead of repeating an exact shape, you can repeat variations on that shape such as twisting lines that would create a sense of flow and movement.

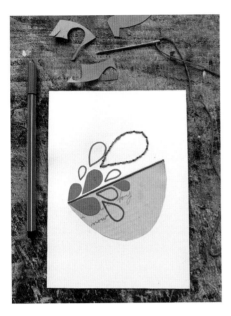

Repeat a color in several different ways within a composition to show unity.

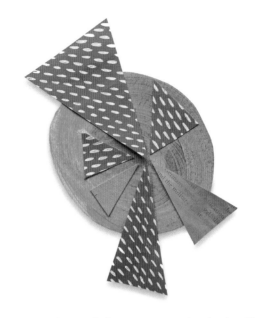

Create a visual texture by featuring a repeated mark using either paint or a drawing tool and create a collage based around it.

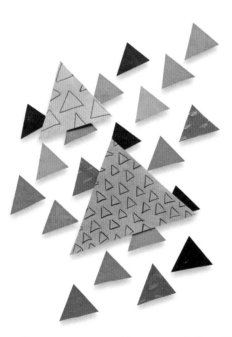

Repeat a design within a composition to create rhythm within your collage.

Choose one shape and many different ways to create that shape—paint, stamping, drawing, or clipped paper—and create a composition by repeating the one shape in many sizes and colors.

BACKGROUND/
FOREGROUND

Most of the time, a background is the first decision you make when composing a collage. Whether it's the paper, canvas, or wood of the bare substrate, the perfect large pattern, or anything in between, what you choose guides the subsequent elements. If you already have a composition in mind at the start of a project, that helps a lot in the background decision making process. If your foreground involves delicate lines, embroidered elements, or intricate shapes, then a chaotic patterned background will devour all of those details and they will become lost in the composition. A solid, light-toned background will help those details stand out. On the other side, if your focal point is a large, neutral shape, then you can add a lot of color, texture, and interest to your work with a bright, patterned background.

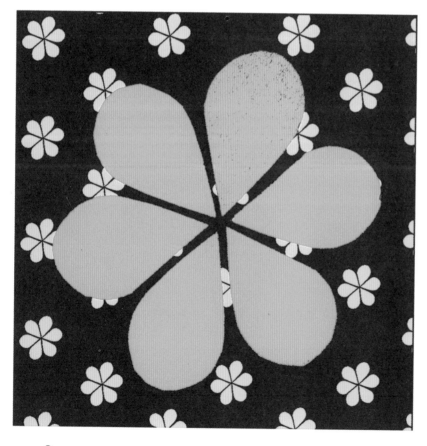

Incorporate some part of your background into your foreground to unify the composition. A few ways can be through repeating color, texture, or pattern.

If your background is a wonderful pattern or busy with texture, then the foreground elements should typically be simple, solid, or neutral so that they stand out and aren't lost in the background.

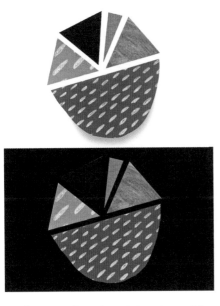

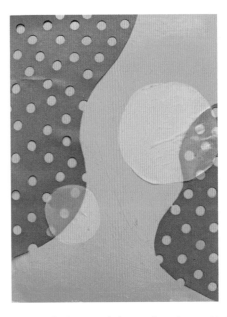

Choose and arrange collage elements based on a white background first. Now, move those same elements to a black background and see how the mood of the work changes. If there any elements that get lost or don't quite work against the black background, then replace them with elements that do and make note of the differences between the removed elements and the added ones.

Add elements to the foreground of your collage that enable the background to peek through. A few ideas are a semitransparent paper element or one with holes, such as a paper doily or something you hole-punch yourself.

LAYERING

When most people think of collage, the first two words that come to mind are "paper" and "layers." We have the paper part down, so now we'll discuss those stacked, fabulous, thick, colorful, textural layers. Think outside the box when choosing the paper for your layers. Tissue paper and vellum are semitransparent and can create interesting results. But paper isn't the only thing that makes layers in a collage. You can add a wash of paint with a paintbrush, spray paint through a stencil, or scribble some texture as well. There are many ways to layer depending on the results you are looking for, and some of those use different adhesives and require specific substrates.

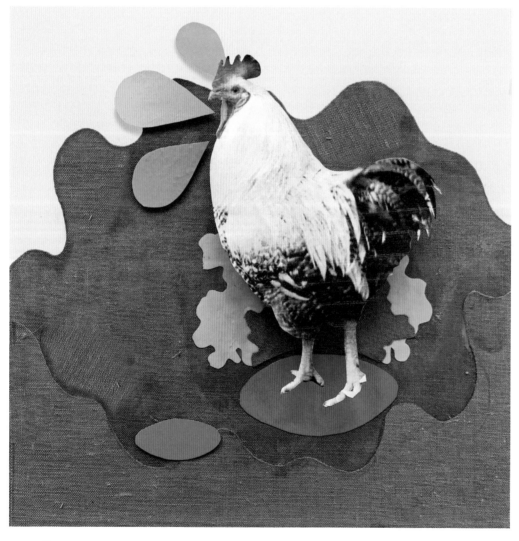

If you have just a few layers and your substrate is paper, then a glue stick will be adequate. Depth can be created within a composition using only two overlapping layers, which is a great way to keep from overworking your collage if you are adding additional elements like embroidery, drawn elements, or paint.

A fun layering exercise starts with a stack of the same shape in varying sizes and different colors and patterns. Start with the largest at the bottom and layer and stack up to the smallest.

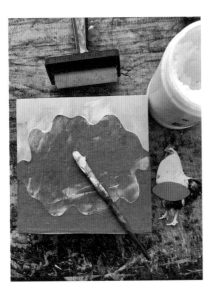

Large compositions with many layers always lead me straight to the gel medium. You will want to build these collages on a canvas or a wooden panel. Start with laying down a coat of gel medium and pressing your background elements into it. Using your brayer or fingers, press the paper into the medium to remove all bubbles and make the surface smooth. Repeat this step with each added layer. You are sandwiching each layer in gel medium, and the result will be a solid, very sturdy surface.

Set your topmost layer above the surface and create an extra layer of depth by using a spacer. Depending on the height that you want, there are several options. You can use cardboard, wooden blocks, or foam that is glued to your surface and then glue your element to that spacer. If you want shallow depth, use foam mounting squares. They are already sticky on both sides and really have a great hold.

SCALE

In the "Principles of Composition" section, we defined scale in composition as the visual comparison between two whole elements. But how can we use scale in our work to demonstrate emotion or ideas, emphasize elements, or offer a new perspective? We, as people, describe the scale of things in relation to ourselves. If something is "life sized," then it is the same proportion as we perceive it in the everyday world in relation to the size of a person. That makes sense. It then also makes sense that when things are smaller or larger than life-sized, we give them names like miniature, tiny, huge, and ginormous (a personal favorite), and these labels, when combined with an object, can create emotion, tension, and joy.

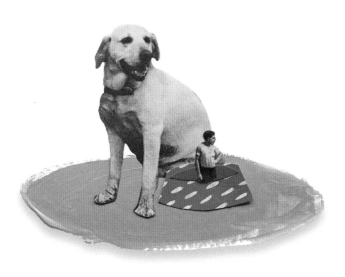

Use a difference in size between two clipped images to illustrate a challenge or problem.

Use scale to draw extra emphasis to the focal point of your composition. Are you telling the viewer something specific about your focal point by doing this?

Make a composition and show a very large version of something that is normally tiny. Does that change your feelings about that item?

Now, make a composition and show a miniature version of something that is normally very large. Did you immediately think, "That's really cute." Or, because of the chosen item, did you have a different emotional reaction?

CONTRAST

We have already discussed contrast as a composition element, so now we're going to apply it in different ways within our collage. To recap, contrast, in its simplest form, in composition, means "difference." This can be a difference in value, color, subject, size, and texture. The more dramatic the difference, like the difference between black and white, the more drama, tension, and interest you can add to your composition. We discussed using color, value, and texture to show contrast, so let's take those a little deeper and tie in other lessons we have learned so far. Let's bring in some common associations with colors and tones such as the idea that red is hot, light tones represent good, squares are sharp, and circles are soft.

Thanks to metaphorical culture, we all know who is who in this color contrast representation of good and evil.

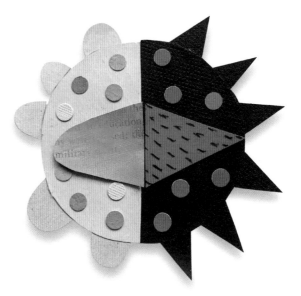

Use contrasting warm (reds, yellows, and oranges) and cool colors (blues, green, and purples) in your composition. Use tints of those colors as well, such as pink and a nice minty green. This should lower the contrast in those areas.

Use a mirror effect in your collage to create two conflicting or opposite feelings. The feeling of two things being opposite can be portrayed through color, contrast, texture, or all of the above.

Use contrasting texture in the elements of your collage to draw the eye to or show importance of the focal point. Think about the contrast between rough textures versus soft or smooth textures. Which looks more appealing?

Try using an inviting focal point that looks soft, smooth, or bright and then a less inviting one that is hard or prickly. How does each of these affect the mood of your collage?

JUXTAPOSITION

Juxtaposition is a relationship story. If an elephant befriends a rabbit, then we feel differently about that duo than we would if an elephant befriended another elephant. This is a reaction to the juxtaposition of an unlikely pairing. An elephant is huge and wrinkly, and, in comparison, a rabbit is tiny and fuzzy. You don't have to feature a huge, wrinkly shape and a tiny, fuzzy shape in your composition to achieve this. Placing any two, or more, contrasting elements side by side creates juxtaposition. This contrast can be achieved through color, subject, texture, and value and usually serves the purpose of bringing out specific qualities of your elements.

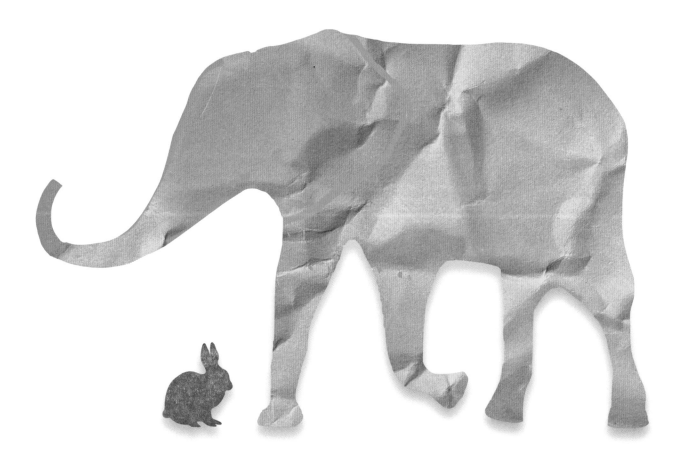

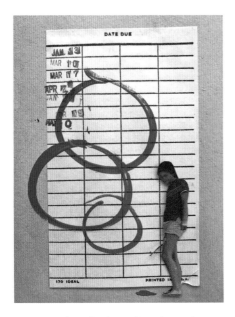

Show juxtaposition through subject. Consider combining modern and vintage or organic and man-made.

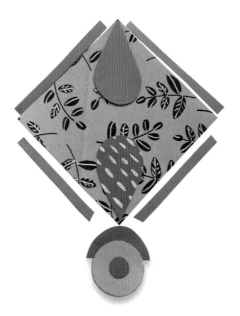

Show juxtaposition through color. Look back to your color wheel! You'll get the most visually pleasing and extreme contrast from colors opposite each other on the color wheel.

Show juxtaposition through texture. Try smooth and rough or marked up and clean.

Show juxtaposition through contrast in value. This can be as extreme as black and white or anything in between.

TEXTURE

There are two kinds of texture in art: *tactile texture* and *visual texture*.

Tactile texture refers to the actual, physical texture of a surface, meaning texture that you can feel. Examples of this are fuzzy pom-poms, wood grain, and sandpaper. A texture doesn't have to be bumpy or gritty to fit into this category. Smooth surfaces like glass and vinyl are also tactile textures and important in combination with rough textures when creating contrast and a feeling of juxtaposition.

Visual texture creates the *illusion* of texture on a material due to mark making and patterns.

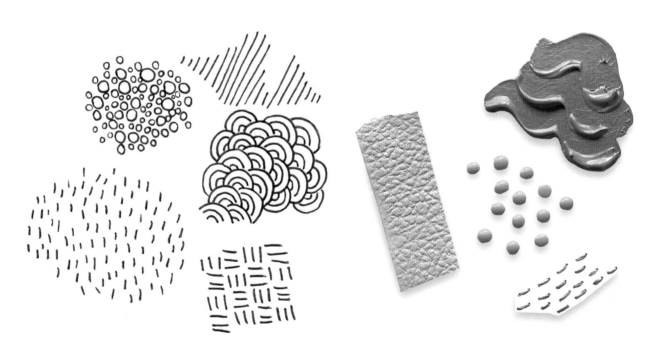

Examples of visual texture Examples of tactile or physical texture

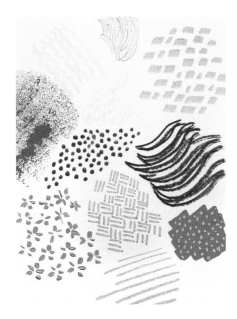

Choose a variety of drawing and mark making tools and create some different visual textures.

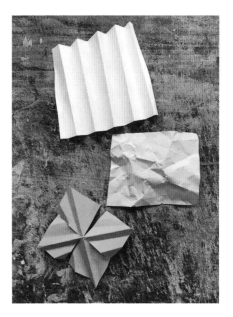

Take several squares of paper and create some tactile texture using only creases and folds.

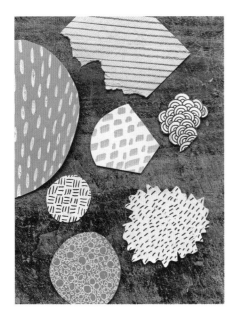

Now, take the textures you created and cut them into different shapes. Clip the edges of a few of your sketched textures into a ragged line to combine tactile and visual texture into one element.

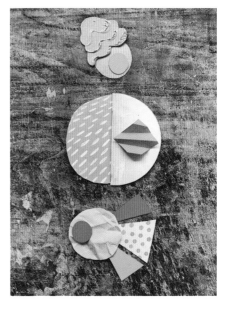

Experiment with the effect they have on balance. Combine them with smooth textures and bright colors.

NEGATIVE SPACE

If the subject or elements of a collage are positive space, then the surrounding area is the negative space. Depending on how it is used, negative space can be just as interesting, or sometimes even more interesting, than the positive space. It can add to a narrative, solidify balance, and define a focal point. The relationship between positive and negative space brings us shape, defines a level of contrast, and can ease and increase tension. When negative space is very limited, a composition can feel full, crowded, or even claustrophobic. When there is a vast expanse of negative space, the elements can feel lost in a composition, and unity between the parts can be a big trickier. Both of these can be important when setting the mood of a piece.

The positive space is in yellow.

The negative space is in yellow.

Become more conscious of negative space and help train your brain to pay attention to the shape of it by sketching the negative space of an object.

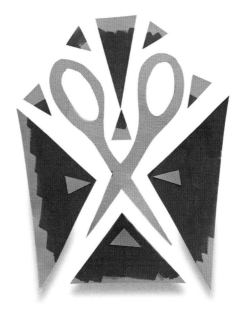

Cut your object out so that you have the object and the space left behind. Use both pieces in a composition.

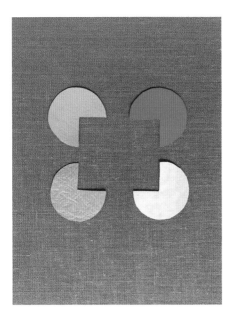

Cut several simple shapes from paper and arrange them in a way so that you create another simple shape using the negative space.

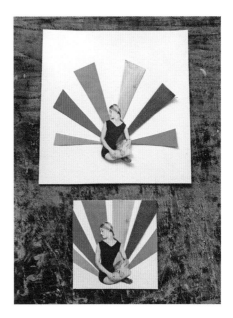

Draw a 4 x 4 inch (10 x 10 cm) box on one side of a sheet of sketch paper and an 8 x 8 inch (20 x 20 cm) box on the other. Choose three to five collage elements and arrange them first in the smaller box and then in the larger box. How does more versus less negative space affect the composition?

SIMPLE VS. COMPLEX

There are a few ways to use the idea of simple versus complex in composition. One is using *simple shapes* and *complex shapes*.

Simple shapes, or geometric shapes, are not often found in nature and can be categorized into groups like ellipses, triangles, and rectangles.

Complex shapes, or organic shapes, are unpredictable and are made up of multiple simple shapes.

You can also use simple and complex patterns, shapes, and textures within a composition to create needed contrast between elements. Think about camouflage in the animal kingdom. An animal hiding in tall grasses, a complex texture, often has a complex pattern to their coat or feathers. Why? Because it makes it extremely difficult to tell the beast from the surroundings. The same is true in composition. Two complex elements side-by-side blend into a busy composition. You can show contrast by setting a complex design or pattern next to a simple one with less detail.

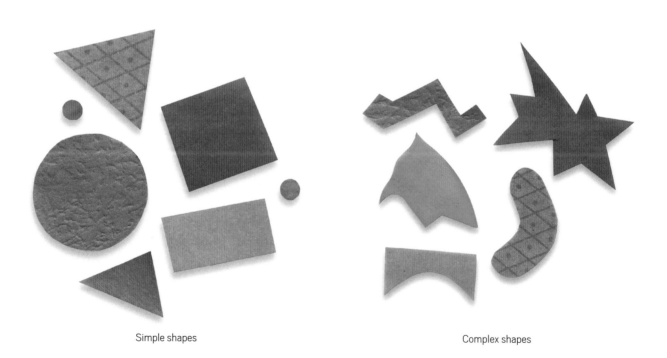

Simple shapes Complex shapes

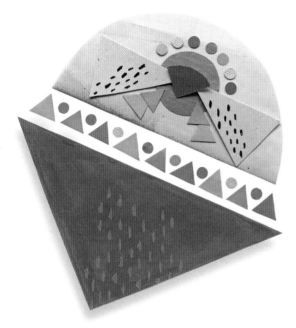

Make a complex composition using simple shapes.

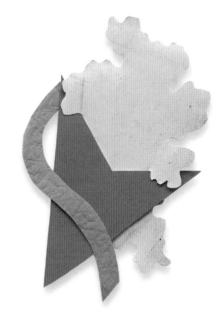

Make a simple composition using complex shapes.

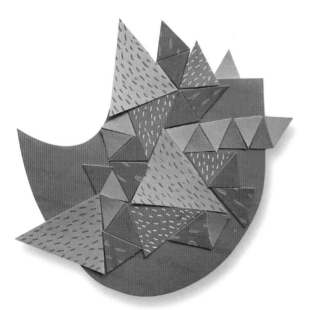

Compose a collage using bits of paper with a lot of texture and similar colors so that when placed side by side, they blend together.

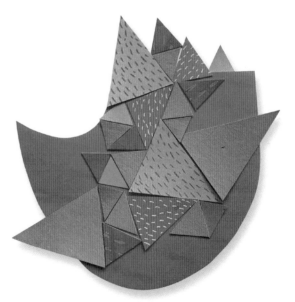

Now, experiment with ways to show contrast. What works best with the paper you have chosen to maintain unity? Try solid colors or a simpler pattern.

FLOW

We've all seen beautiful photographs of winding rivers cutting back through a forest scene. The water is usually blurry as it moves over rocks in its path. This is a perfect example of flow. We can feel the flow of the water as well as the flow created within the composition as our eyes follow the path of the river through the scene. Water is one of the first things that comes to mind when you hear the word flow, but we can create that in other ways too. Your eyes will flow through a composition and follow a visual path created by a progression of like elements. The components can be alike in shape, color, or both and should be close enough in proximity to one another so that it doesn't appear to be a random placement but instead creates a directional path.

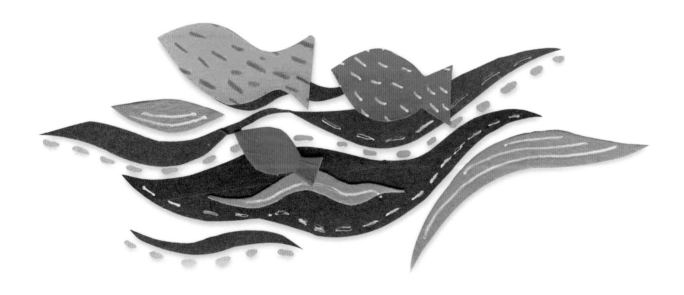

Take a collection of tiny clipped elements in two different sizes or colors. Arrange one size or color in a metered, even way across your composition.

Next, take your different clippings and replace your first set, a few at a time, until you have created a winding flow within your composition.

Cut some long, organic, similar shapes of roughly the same size. Place them all facing the same direction to create a pattern across your substrate. What feeling of flow do you get from this?

Now, cut some more of the same shapes but make them different sizes. Arrange your shapes, larger at the bottom and getting smaller as they move back to a focal point. You still get a feeling of flow, but this method leads your eye back through your composition.

SHAPE

A shape is any two-dimensional space enclosed by a line or defined by some kind of contrast or difference between it and the surrounding space. And all of the countless shapes in the world fall under two categories: *geometric shapes* and *freeform shapes*.

Geometric shapes are those that math can be applied to and are usually man-made. Circles, rectangles, triangles, and trapezoids are all geometric shapes.

Freeform or organic shapes are unpredictable, have no rhyme or reason, and are found in nature. Organic shapes do whatever they want, and we love them as they make everything more interesting.

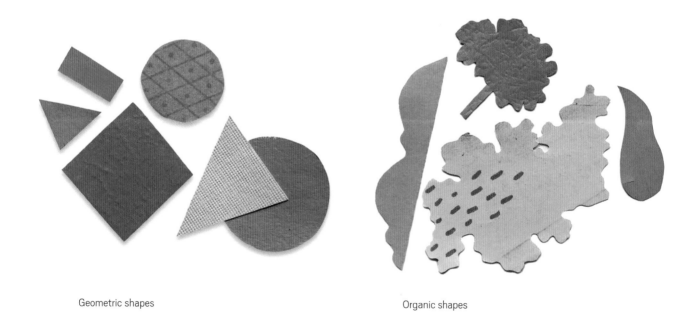

Geometric shapes Organic shapes

Use many small shapes together, but not touching, to imply a larger shape.

Take a clipped image with multiple parts to it, such as a person, and clip away a large portion, leaving empty space. Your eyes will recognize the missing shape, and your composition becomes more visually interesting.

Start with a rigidly geometric shape, such as a square, and combine that with either clipped or found organic shapes to create a balanced composition.

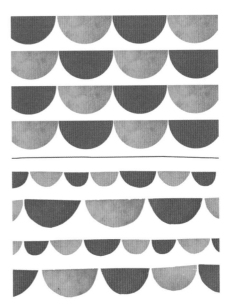

Create a simple pattern using precisely clipped geometric shapes (use a stencil to make this easier) and arrange them on a substrate without gluing them down. Now, take each shape and alter it slightly to make it more organic and different from the shapes around it. How does the feel of the pattern change?

LINE

Line is one of the more diverse elements of composition. It can be used to draw eyes to the focal point, show movement, add depth, divide or unite elements, and lead your eyes through a work. Lines can be solid, broken, or implied, have any number of thicknesses, and be straight or curved. There are countless types of line and just as many ways they can be used in your collages. In these exercises, try making your own lines, either cut from paper or drawn and painted, and also find lines from your paper materials as well. The eaves of a house or edge of a horizon can make a beautiful line when clipped away from the rest of the image.

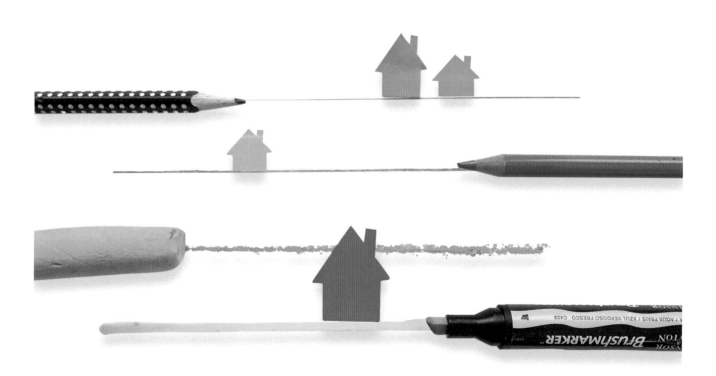

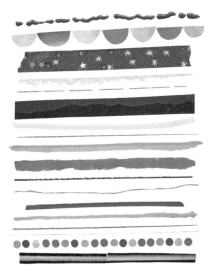

Take a sheet of mixed media paper and see how many types of lines you can make. Work your way through your mark making tools and pay attention to what lines look harsh and sharp and what lines look soft. Make implied lines with scattered dots and clip some from your paper collection. This is also a good warm-up exercise for the start of any creative day! You can also clip these lines apart into strips and save them for later use.

Use line to show depth and guide the viewer's eyes to a focal point in your work.

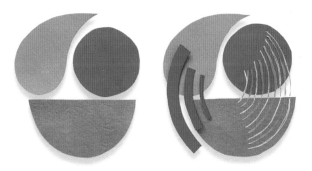

Place three separate clipped paper shapes anywhere on your paper and make sure they aren't touching. Now, use any line you want to connect these elements into a unified composition. The lines can be varying colors, thickness, and media.

Choose some of your strips of lines that we made in the first exercise and combine them with drawn elements to make a grid. It can be made of equal squares or spaced to make different sizes. Now, fill in a few of the squares across your grid, paying attention to keeping the composition evenly balanced using texture and color.

USING TYPE

Much of my background is in graphic design (shout out to my Adobe Creative Suite friends) and with this comes a great love for fonts. Just like color, the look of a font can change the entire mood of a design and can have geometric or organic properties depending on curves, thickness, and angle. Does that last part sound familiar? It should! It brings us right back to the properties of shapes. You can incorporate entire words into your work, which can be an interesting way to achieve an added layer of meaning, but we're going to stick to using letters as shapes and texture. So, dig around for those old newspapers with that glamorously designed, dreamy headline type!

Take a page out of a book and apply a thin layer of acrylic paint or gouache right over the top. You'll be able to see the letters show through, and it adds an interesting texture. Add layers of paint until you get the look that you want.

Using a book page or any block of text, cut the sentences into strips of the same width and glue them to your substrate or other paper to create patterns of texture. If you use gel medium to soak the strips first, then while they're still wet, you can carefully bend them into curves.

Gather a pile of larger letters of the same color. You can either make these letters or clip them, and they can be painted if you don't find enough of the same color. Make a composition, blending and mixing the letters at all angles, until you see them as shapes and not individual letters.

Trace or draw one large letter of your choice onto your substrate and fill the space with collage elements. They can be themed, the same or different colors, or anything you want! You can completely stay within the borders or poke a few elements over the edges. See where the letter takes you.

USING NATURE

There is so much inspiration right outside your door. A morning walk will clear out the mental cobwebs and open up your mind to create. If you have been working in a tight geometric style, then these organic, imperfect, unpredictable shapes are a great way to break out and loosen up your work. As you walk, pick up some natural elements that catch your eye along the way and then bring them back to your studio or kitchen table and see where they take you. Snap some pictures of that perfect color in the sky and the repeated pattern in a dry riverbed for further inspiration. Once you sit down with your materials, here are some ideas to get you started.

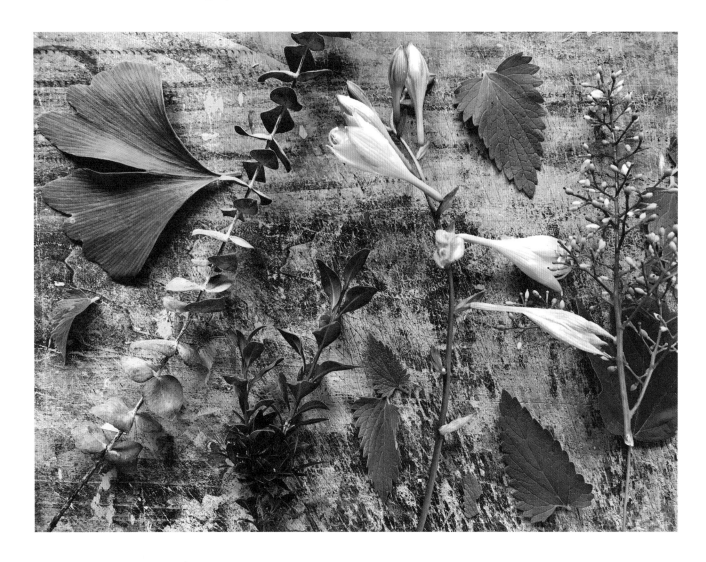

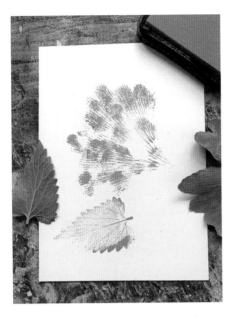

Find leaves with interesting shapes (ginkgo is one of my favorites) and use an ink pad or paint and brush to make a stamp from the leaf.

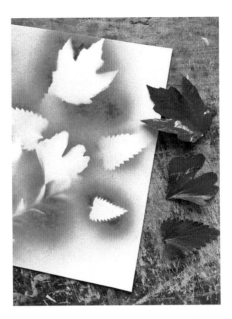

Gather flowers with stems, leaves, twigs, and other shapes and arrange them on your substrate or other paper. Spray over the top with spray paint and wait for it to dry. When you remove the natural elements, they will leave their shape in negative space.

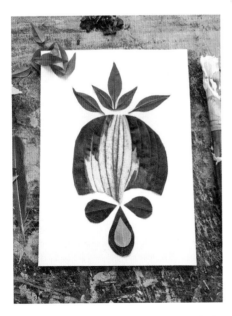

Use dried leaves, flower petals, shells, seed pods, and other natural findings as elements in your collage. Gel medium or another stronger adhesive will work best for larger or heavier pieces.

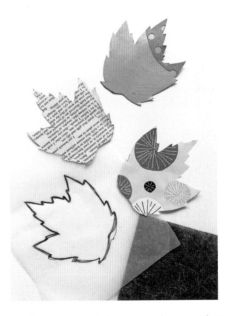

Trace around larger shapes like leaves (or make a stencil using vellum) and cut them from different types of paper to make a leaf-themed repeating pattern.

SKETCHBOOKING

Yes, I did make a verb out of "sketchbook." This set of challenges is a little different than the others. As a perfectionist, I sometimes find myself all bound up in trying to get what is in my head out onto the paper. The more bound up I get, then the more dissatisfied I become with what I am making, and that creative brick wall gets closer and closer. I lose the ability to see any potential in the art I am making because all I can see is the art I am failing to make. Keeping a loose, collage sketchbook will help with this so much. It's not a place for masterpieces, it's a place to practice and get messy and stumble upon new ideas and skills. It's a place to try out all of these collage challenges that we have just worked through so you can look back and see what you have done, how far you've come, and your style breaking through. If you have not experimented with collage before, then this is a learning process. Be kind to yourself. Make mistakes and embrace them. Some mistakes will teach us what we don't want to repeat, and some mistakes will lead you on a direct path to your personal style. Either way, mistakes are necessary.

When you choose your collage sketchbook, do a bit of research first. You will eventually land on one that is perfect for you, and you will never stray from it, but you might have to try some out. Find one with sturdy covers and multimedia paper to withstand the adhesives and paint and whatever else you want to throw at it. Another helpful tip, some mixed media books have a pocket on the back cover that is perfect to store clippings as you find them, which is really a great help if you collect things from the wilds of your day.

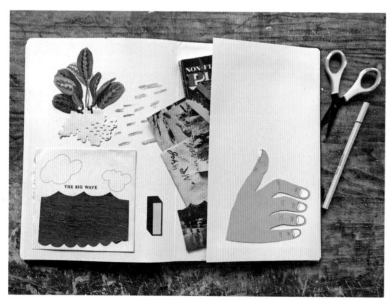

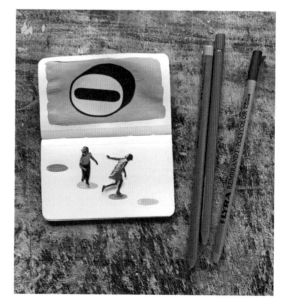

IN THE END

As you venture into the world of collage, be inspired, keep creating, and always remember the following:

Don't be afraid to get messy.

Stay open.

Stay loose.

Stay true to your creative self.

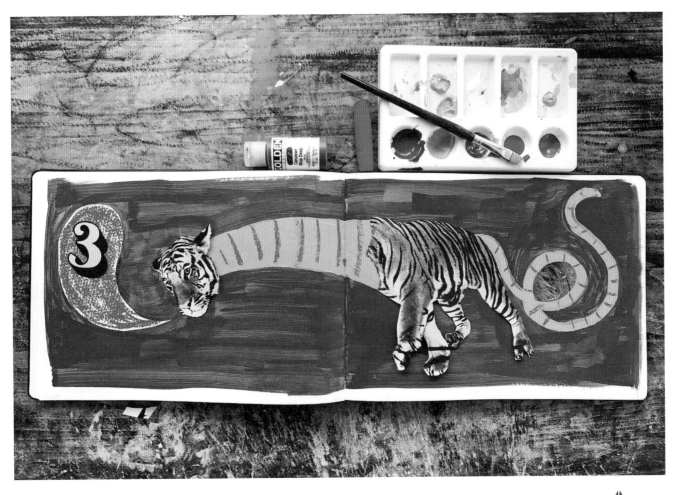

ABOUT THE AUTHOR

Hollie Chastain is a collage artist and illustrator based in Chattanooga, Tennessee. After studying a combination of fine art and design in school, she spent several years as a graphic designer. In 2009, she left the office and headed back to the studio to get her hands messy and delve into analog work again and has been steadily building an illustration and fine art career since. Hollie works mainly with paper, mixing vintage and found images with modern colors and compositions to create work full of originality and narrative that has been featured on the cover of books, album art, installations, and more. As well as in various publications, you can see her work in galleries and art boutiques both in the United States and abroad. She is married with two children and a house full of rescue pets.

ACKNOWLEDGMENTS

I started this project thinking, "I can definitely do this!" and then I *actually started* and was reminded by panic that I had never attempted to put together a book. Thank you, panic. But, with help and encouragement, I completed it, had a great time, and learned a lot in the process. Thank you to the lovely Mary Ann Hall and everyone at Quarry Books for this opportunity, your guidance, and your patience. Thank you to each of my past art and design teachers for all of those pop quizzes on rules of composition, even though I grumbled every time. And, finally, I cannot thank my family enough for being so great and supportive of me in my career through all of the sometimes long, sometimes stressful, sometimes wonderful, always fulfilling times that come along with it. Thank you to my kiddos for inspiration and joy. And thank you, Eric, my favorite person.

PRETTY PAPER

Are you feeling extra inspired and want to cut and paste something right this second? I don't blame you. I feel that way a lot. It's a good feeling. So here's a little head start on your paper collection!

You'll find a few familiar characters, colors, and patterns to get your collage engine going and work your way through some of the exercises in this book. Next, you can go out into the world and start gathering scraps, colors, and ephemera that are personal to you and your developing style. That stack of magazines hiding in your closet is a great place to start, and junk shops, antique stores, used book stores, and yard sales are often where you can find older materials.

The images supplied here are public domain images or made from scans of old black and white photographs that I picked up here and there. The rules concerning copyright protection on images can be a bit of a grey area, so read up and make decisions that you are comfortable with. If you want to be extra careful, there are countless resources for public domain images and photos online. And that box of ancient family photos, a scanner, plus a printer equals gold.

Have fun!!

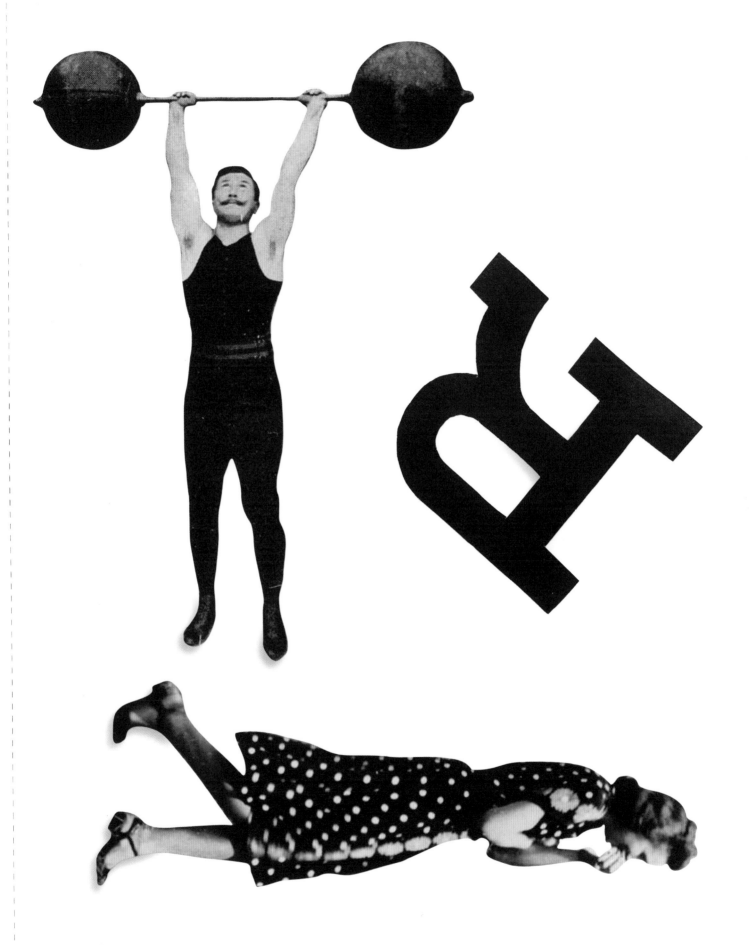

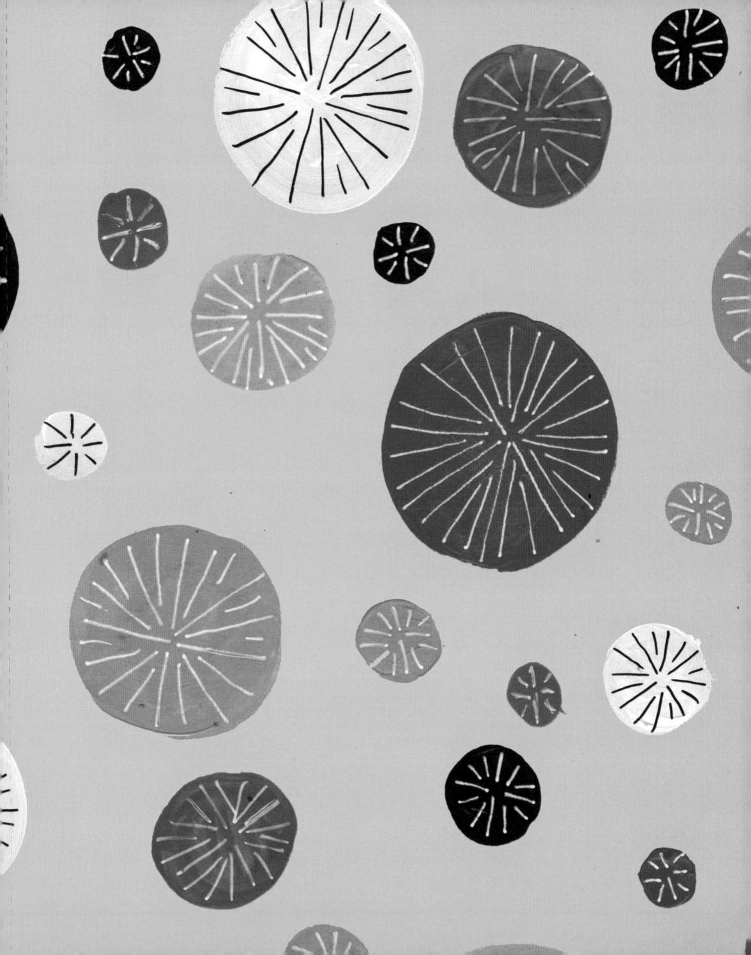

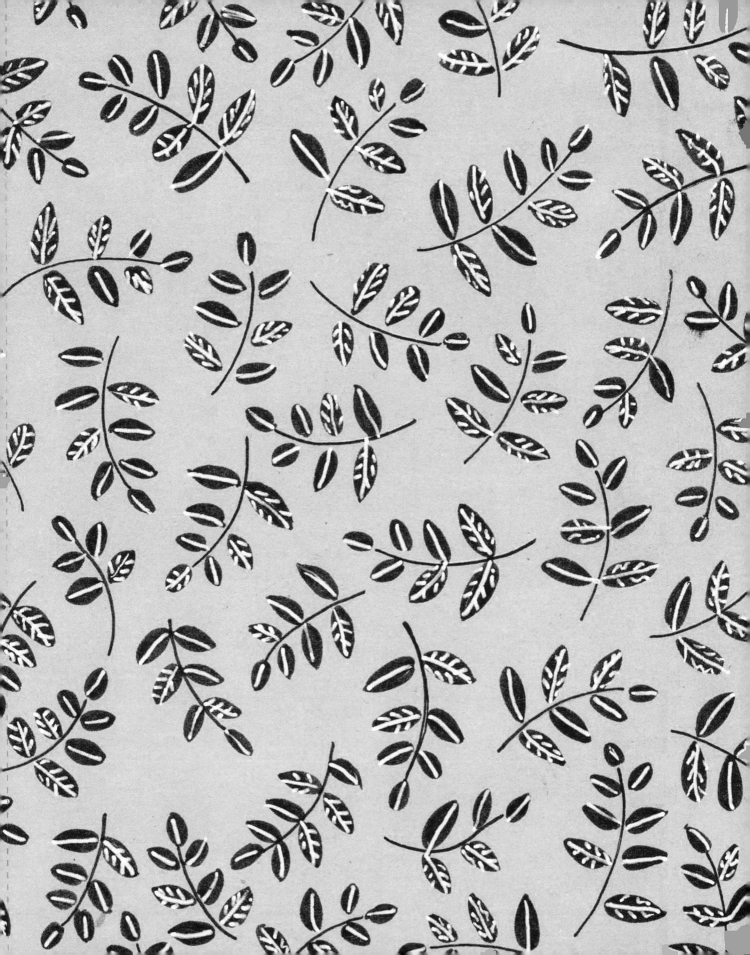

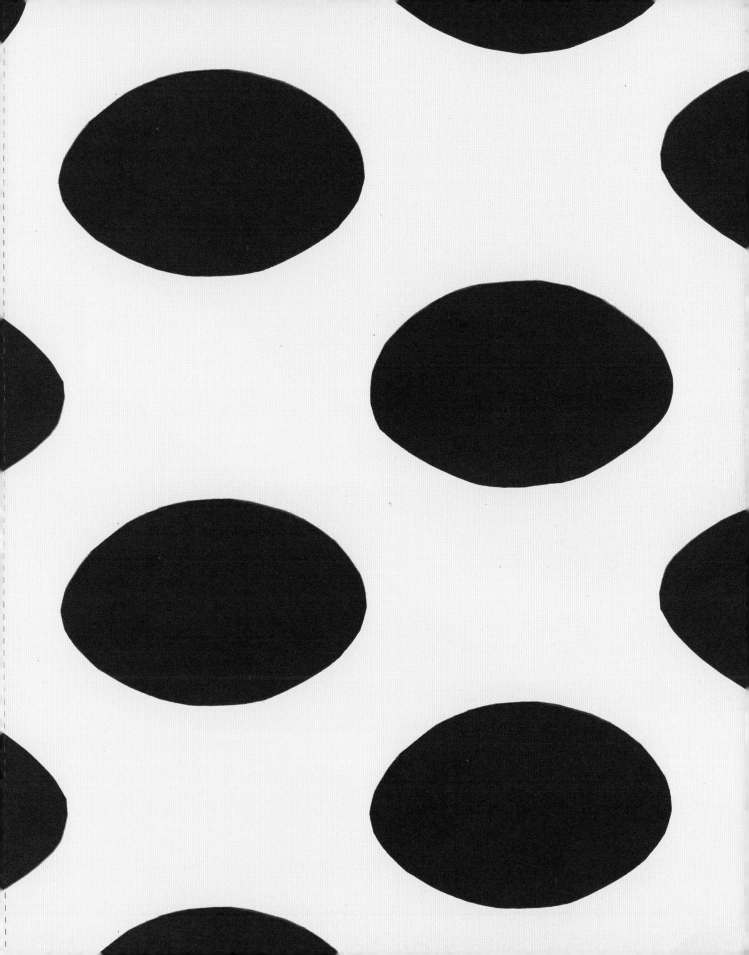

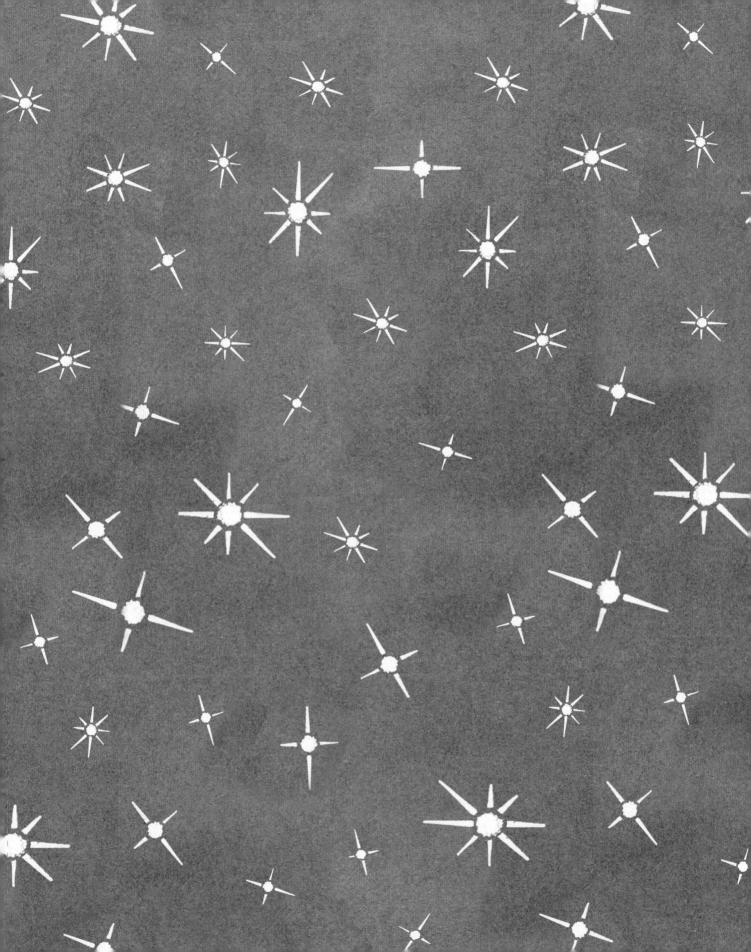